HEAD OF DEPARTMENT
Arts & Adults Studies
Floor 3
Scarborough Technical College
Lady Ediths Drive
Scarborough

8
4

EDITED BY, EDITÉ PAR, HERAUSGEGEBEN VON EDWARD BOOTH-CLIBBORN

THE FOURTH ANNUAL OF EUROPEAN EDITORIAL, BOOK POSTER, ADVERTISING

AND UNPUBLISHED PHOTOGRAPHY

LE QUATRIEME ANNUAIRE EUROPÉEN DE PHOTOGRAPHIES DE PRESSE,

DU LIVRE, DE L'AFFICHE, DE LA PUBLICITÉ ET D'OEUVRES NON PUBLIÉES

DAS VIERTE JAHRBUCH DER EUROPÄISCHEN REDAKTIONS-BUCH-,

PLAKAT-, WERBE- UND UNVERÖFFENTLICHTEN FOTOGRAFIE

EUROPEAN PHOTOGRAPHY 12 CARLTON HOUSE TERRACE LONDON

Book designed by Cooper Thirkell Limited.

Editorial production: Ros Schwartz.

The Exhibition of the photography in this book will be shown at The National Theatre, London.

The captions and photography in this book have been supplied by the entrants. Whilst every effort has been made to ensure accuracy, European Photography do not, under any circumstances, accept responsibility for errors or omissions.

No part of this book may be reproduced in any manner whatsoever without written permission.

Cover photograph by Barney Edwards.

Photographs of the Jury by Michael Joseph.

Maquettistes du livre Cooper Thirkell Limited.

Rédactrice du texte: Ros Schwartz.

L'exposition, d'oeuvres d'art de ce livre aura lieu à The National Theatre, Londres.

Les Légendes et les oeuvres d'art figurant dans ce livre ont été fournies par les personnes inscrites. Bien que tout ait été fait pour en assurer l'exactitude, European Photography n'accepte aucune responsabilité en cas d'erreurs ou d'omissions.

Aucune partie de ce livre ne peut être reproduite en aucune façon sans autorisation écrite.

Photographie de couverture par Barney Edwards.

Photographies du Jury par Michael Joseph.

Buch gestaltet von Cooper Thirkell Limited.

Textredaktion: Ros Schwartz.

Die Ausstellung der in diesem Buch gezeigten Fotos findet statt im National Theatre, London.

Die textlichen Angaben zu den Abbildungen und die Vorlagen dazu wurden uns von den Einsendern zur Verfügung gestelet. Der genauen Wiedergabe wurde größte Sorgfalt gewidmet; European Photography kann jedoch unter keinen Umständen die Verantwortung für Fehler oder Auslassungen übernehmen.

Die Wiedergabe dieses Buches vollständig oder in Auszügen in jedweder Form ist ohne schriftliche Genehmigung nicht gestattet.

Umschlag-Foto von Barney Edwards.

Fotos der Jury von Michael Joseph.

European Photography Call for Entries Copyright ©1984

The following companies hold the exclusive distribution rights for European Photography 83/84:

France: Sofédis, Paris

USA/Canada: Harry N Abrams Inc., New York

UK: Devonshire House, 29 Elmfield Road, Bromley, Kent BR1 1LT Tel: 01-290 6611

Rest of the world:
Fleetbooks, 100 Park Avenue, New York, NY 10017

Printed in Japan by Dai Nippon. Paper: 157GSM coated
Typeface: News Gothic
Filmset by: The Setting Room, London

Published by Fleetbooks S.A. Switzerland
Copyright ©1984

779

27263
19409

Anyone familiar with earlier editions of European Photography will perhaps notice that this fourth annual is a smaller book than usual.

Nevertheless, the quality of the work is as high as ever.

This is because, although we have a policy of never giving awards, we do look for the most outstanding photographs of the year and reject the mediocre.

Looking through this book I'm sure you'll agree we've achieved our objective. For myself, I know that the key to our selection lies in composition. Whether we're looking at editorial, advertising or fashion photography, or work by amateurs or professionals, we are always aware of composition above all else. After all, just as in painting, the artist's ability to follow the rules and grammar of composition is just as important as his or her ability on a technical level. The eye, as ever, is only as good as the discipline it's subject to.

If you're looking at this book for the first time, you may wonder how its contents are brought together.

Initially, photographers are asked to submit their work to a jury who then study each submission and decide on its suitability for inclusion. In the main, we get most of our work from professionals. However, the section which includes work previously unpublished is open to amateurs. If you're a keen amateur, and would like to see your work published alongside some of the most talented of Europe's photographers, do submit your work for next year's annual. If it is selected you'll not only be in classic company, your work will be seen all over Europe, and in the USA. European Photography has, over the years, become well known – and well thought of – in all these countries.

If your interest is confined only to looking at pictures, I hope you'll enjoy this selection. Many of the pictures were designed to work with words, but, I think you'll agree, they work equally well just as pictures.

Ceux qui connaissent les éditions précédentes d'European Photography remarqueront peut-être que ce quatrième annuaire est un peu plus mince que d'habitude.

Néanmoins, la qualité du travail est excellente, comme toujours. Cela parce que, malgré notre politique de ne jamais donner de prix, nous cherchons les photographies les plus remarquables de l'année et nous rejetons tout ce qui est médiocre.

Je suis certain qu'en feuilletant ce livre, vous serez de l'avis que nous avons realisé notre objectif. Pour ma part, je sais que notre choix se base sur la composition. Qu'il s'agisse de photographies de presse, de photographies publicitaires ou de mode, un travail d'amateur ou de professionel, nous tenons toujours compte de la composition avant tout. Après tout, comme pour la peinture, la capacité de l'artiste pour respecter les règles et la grammaire de la composition est aussi importante que sa capacité au niveau technique. L'oeil, comme toujours, est seulement aussi bon que la discipline à laquelle il doit obéir.

Si vous regardez ce livre pour la première fois, vous vous demanderez peut-être comment nous avons réuni les travaux présentés.

Au depart, les photographes sont invités à soumettre leur travail à un jury qui, par la suite, étudie chaque photographie et décide di l'inclure ou non. En général, la plupart des soumissions viennent des professionels. Cependent, la categorie de travaux inédits est ouverte aux amateurs. Si vous êtes amateur passionné, n'hésitez pas à concourir l'année prochaine. Si votre travail est selectionné, non seulement serez-vous en compagnie classique, mais aussi votre travail sera vu partout en Europe et aux Etats-Unis. Dans tous ces pays, au fil des années, European Photography est devenu bien connu et bien respecté.

Si vous êtes plutôt quelqu'un qui préfère regarder les images, j'espère que cette sélection vous plaise. Beaucoup des images étaient prevues pour accompagner un texte, mais je crois que vous les trouverez aussi impressionantes comme simples images.

Wenn Sie mit früheren Ausgaben der European Photography familiär sind, werden Sie vielleicht bemerken, daß das vierte Jahrbuch eine kleinere Ausgabe ist.

Die Qualität der Arbeiten ist dennoch keineswegs minderwertiger.

Der Grund liegt darin, daß, obwohl wir niemals Auszeichnungen verleihen, wir weiterhin die hervorragendsten Fotos des Jahres suchen und jegliche Mittelmäßigkeit ablehnen.

Wenn Sie sich die Bilder in diesem Buch ansehen, werden Sie sicher auch der Meinung sein, daß wir unser Ziel erreicht haben. Ich persönlich glaube, daß der Schlüssel für unsere Auswahl in der Komposition liegt. Ob wir uns nun mit redaktioneller-, Werbe- oder Modefotografie beschäftigen, oder mit Arbeiten von Amateuren oder Berufsfotografen – wir sind uns immer insbesonders der Komposition bewußt. Wie in der Malerei ist schließlich die Fähigkeit des Künstlers, nach den Regeln und der Grammatik der Komposition zu arbeiten, ebenso wichtig wie seine oder ihre Fähigkeit im technischen Bereich. Das Auge ist eben nur so gut wie die Disziplin, der es unterlegen ist.

Wenn Sie sich dieses Buch zum ersten Mal ansehen, werden Sie vielleicht rätseln, wie der Inhalt zusammengetragen wird.

Zuerst werden Fotografen gebeten, ihre Arbeiten einzusenden. Diese Arbeiten werden dann in Hinsicht auf deren Veröffentlichung individuell von einer Jury gewertet. Ein Großteil dieser Einsendungen kommt von Berufsfotografen. Die Kategorie für unveröffentlichte Arbeiten ist jedoch auch Amateuren offengestellt. Wenn Sie begeisterter Amateur sind und Ihre Arbeiten neben denen der talentiertesten Fotografen Europas veröffentlichen möchten, dann schicken Sie uns bitte Ihre Arbeiten für das nächste Jahrbuch. Falls sie ausgewählt werden, befinden Sie sich nicht nur in der Gesellschaft der Klassiker, Ihre Arbeiten werden darüberhinaus in ganz Europa und in den U.S.A. gesehen. European Photography ist im Laufe der Jahre in all diesen Ländern wohlbekannt geworden.

Wenn sich Ihr Interesse darauf beschränkt, die Bilder zu betrachten, dann hoffe ich, daß Sie diese Auswahl genießen. Viele der Fotos sollten ihre Wirkung im Zusammenspiel mit Worten erreichen, aber sie gelten – wie ich glaube – ebenso gut nur als Bilder.

1
2

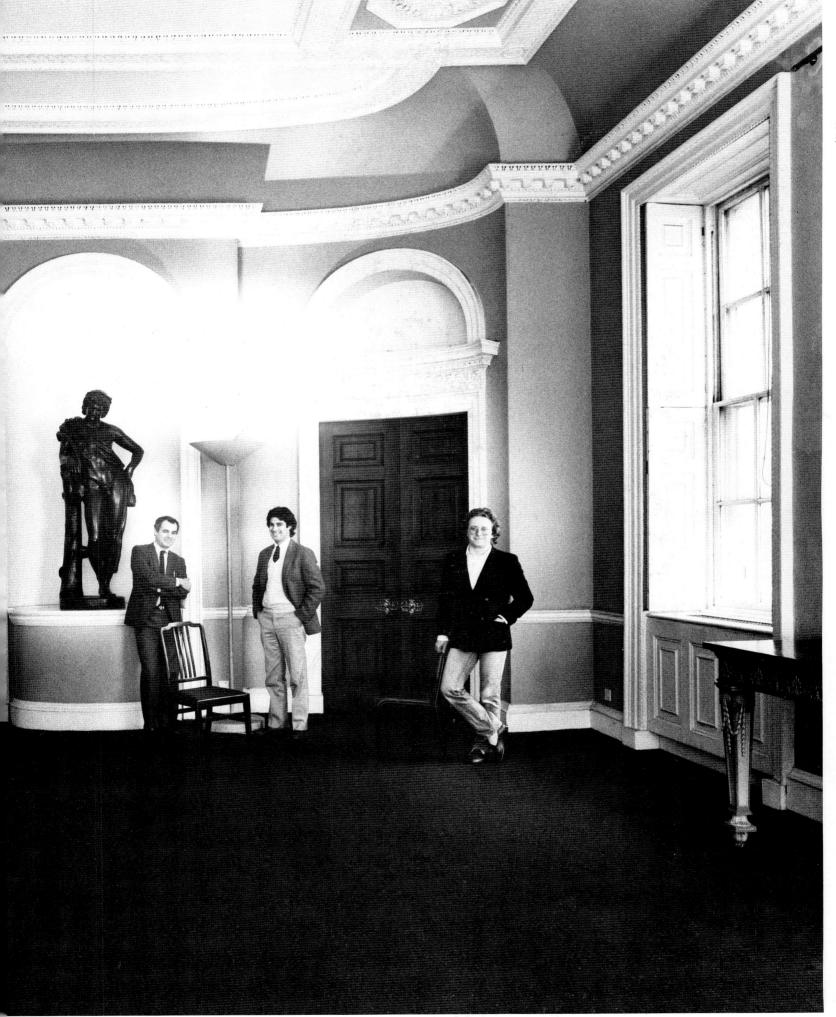

Martin Pedersen. Director of Jonson Pedersen Hinrichs & Shakery Inc., New York.

Martin Pedersen began his career in advertising, working for a number of major agencies and design studios. In 1966, he became corporate Design Director for American Airlines. He opened his own studio in 1968 and won many awards in all creative areas. 1976 saw the beginnings of the present partnership with Jonson, Hinrichs and Shakery and the company now enjoys an international reputation. Martin Pedersen has taught and lectured in schools, universities and at conferences up and down the country and served on juries for major shows and design competitions. He is a member of the Board of Directors of the American Institute of Graphic Arts, the Art Directors Club of New York and the Society of Illustrators.

Wolfgang Behnken. Art Director, Stern Magazine.

Wolfgang Behnken studied visual communications at the Wuppertal College of Applied Art, during which time he won an award for his film about children's education. After leaving college he worked for an advertising agency on the Social Democrats' General Election campaign. He then moved to "Stern Magazine," where he currently works as Art Director.

James Danziger. Picture Editor of the Sunday Times Magazine.

James Danziger was born in 1953 and studied at Yale University, U.S.A. He joined the Sunday Times in 1978 as Assistant Picture Editor of the newspaper and was made Picture Editor of the magazine in 1982. He is to become Features Editor of Vanity Fair in June 1984.

He has published two books: *Interviews with Master Photographers, 1977*, Paddington Press, London and *Beaton* Edited and with text by James Danziger, 1981, Viking, New York; and Secker and Warburg, London.

Floris de Bonneville. Editor of Gamma Press Agency, Paris.

Floris de Bonneville was born in St Etienne, France, in 1941. He was interested in photography from a very early age and when he was fifteen, he started an illustrated magazine for schoolchildren which sold 5,000 copies over two years.

He studied journalism in Lille and then spent a year in New York as a correspondent for *France Soir* and subsequently as copy-boy for the *Daily News* – "the best school of journalism", he says.

After his military service, he worked for a year on a daily paper in St Etienne, and then in Metz before going to Paris to work in his first photgraphic agency, l'Agence Dalmas.

Three years later, in 1968, he joined Gamma of which he is now the Editor.

Paul Arden. Deputy Creative Director at Saatchi & Saatchi

Paul Arden spent the first twenty years of his career as an art director learning and doing what shouldn't be done. Including getting fired five times. He has spent the last six years of his career doing what should be done and is still learning how to do it.

Photograph of the jury on pages 12 and 13 from left to right: Paul Arden, Martin Pedersen, Floris de Bonneville, James Danziger and Wolfgang Behnken.

Martin Pedersen. Directeur de Jonson Pedersen Hinrichs & Shakery Inc., New York.

La carrière de Martin Pedersen a debuté dans la publicité où il a travaillé pour plusières grandes agences et design studios. En 1966, il est devenu directeur de design pour American Airlines. Il a ouvert son propre studio en 1968 et il a gagné de nombreux prix dans tous les domaines créatifs. 1976 a vu les débuts de l'association actuelle entre Pedersen et Jonson Hinrichs et Shakery et la compagnie jouit maintenant d'une réputation internationale. Martin Pedersen a enseigné dans des écoles et il a donné des conférences dans des universités à travers le pays. Il a été membre de nombreux juries pour des concours importants. Il est membre du conseil d'administration du American Institute of Graphic Arts, l'Art Directors Club of New York et la Society of Illustrators.

Wolfgang Behnken. Directeur Artistique du 'Stern Magazine'.

Wolfgang Behnken a étudié les communications visuelles au College d'Art Appliqué de Wuppertal, et pendant ce temps il a gagné un prix pour son film sur l'éducation des enfants. Après avoir quitté le collège il a travaillé pour une agence de publicité en faveur de la campagne des Sociaux Démocrates pour l'Election Générale. Il est ensuite entré à "Stern Magazine," où il travaille actuellement comme Directeur Artistique.

James Danziger. Directeur de Photographie du Sunday Times Magazine.

Né en 1953, James Danziger a fait ses études à l'université de Yale, U.S.A. Il est entré au Sunday Times en 1978 comme assistant au directeur de photographie du journal, et il est devenu directeur de photographie du magazine en 1982. En juin 1984, il deviendra rédacteur-en-chef de Vanity Fair.

Il a publié deux livres: *Interviews with Master Photographers* (Entretiens avec des grands photographes), 1977, Paddington Press, London et *Beaton* Edité et écrit par James Danziger, 1981, Viking, New York; et Secker and Warburg, London.

Floris de Bonneville. Rédacteur-en-chef du l'Agence Gamma, Paris.

Floris de Bonneville est né à Saint Etienne, France, en 1941. Trés vite, il s'est passionné pour le journalisme puisqu'à l'âge de 15 an il lançait un magazine illustré pour lycéens qui, pendant 2 ans, tira à 5000 exemplaires.

Après l'école de journalisme de Lille, il partit un an à New York, correspondant de *France Soir* puis copy-boy au *Daily News*. "La meilleure école de journalisme," dit-il.

Après son service militaire, il poursuivit son expérience journalistique pendant un an dans un quotidien de St Etienne puis de Metz, avant de venir à Paris faire ses premières armes dans une agence photo, à l'Agence Dalmas.

Trois ans plus tard, en 1968, il entrait à l'Agence Gamma dont il est maintenant le rédacteur-en-chef.

Paul Arden. Directeur de création adjoint, Saatchi & Saatchi.

Paul Arden a passé les premiers vingt ans de sa carrière à faire ce qu'il ne fallait pas. Y compris, il s'était fait licencier cinq fois.

Il a passé les derniers six ans de sa carrière à faire ce qu'il fallait et il est toujours en train d'apprendre comment le faire.

Martin Pedersen. Direktor, Jonson Pederson Hinrichs & Shakery Inc., New York.

Martin Pedersen begann seine Karriere in der Werbebranche und arbeitete für eine Reihe von namhaften Agenturen und Design-Studios. 1966 wurde er Design Direktor der American Airlines. 1968 gründete er sein eigenes Studio und gewann etliche Auszeichnungen in allen kreativen Bereichen. Im Jahre 1976 trat er zusammen mit Jonson, Hinrichs und Shakery in die jetzige Partnerschaft ein, die heute einen internationalen Ruf genießt. Martin Pedersen hat überall im Land in Schulen, Universitäten und Konferenzen Vorlesungen abgehalten und war Jury-Mitglied bei bedeutenden Ausstellungen und Design-Wettbewerben. Er ist Mitglied des Vorstandes des American Institute of Graphic Arts, des Art Directors Club of New York und der Society of Illustrators.

Wolfgang Behnken. Art Direktor, 'Stern'.

Wolfgang Behnken hat visuelle Kommunikation an der Hochschule für angewandte Kunst in Wuppertal studiert und gewann während dieser Zeit eine Auszeichnung für seinen Film über Kindererziehung. Nach Abschluß seiner Ausbildung arbeitete er für eine Werbeagentur an der Wahlkampagne der Sozialdemokraten. Danach wechselte er über zum "Stern," wo er derzeitig als Art Direktor tätig ist.

James Danziger. Bildredakteur des Sunday Times Magazine.

James Danziger, geboren 1953, hat an der Yale Universität in den U.S.A. studiert. 1978 begann er bei der Sunday Times als assistierender Bildredakteur der Zeitung und wurde 1982 Bildredakteur der Farbbeilage. Im Juni 1984 wird er Reportage-Redakteur der Vanity Fair.

Er hat zwei Bücher veröffentlicht: *Interviews with Master Photographers,* (Interviews mit Meistern der Fotografie), 1977, Paddington Press, London und *Beaton,* Text und Redaktion von James Danziger, 1981, Viking, New York; und Secker and Warburg, London.

Floris de Bonneville. Redakteur der Gamma Presseagentur, Paris.

Floris de Bonneville wurde 1941 in St Etienne in Frankreich geboren. In frühen Jahren entdeckte er sein Interesse an der Fotografie und begann im Alter von 15 Jahren eine illustrierte Zeitschrift für Schulkinder, von der über zwei Jahre 5,000 Kopien verkauft wurden.

Er hat Publizistik in Lille studiert und verbrachte dann ein Jahr in New York als Korrespondent für *France Soir* und danach als 'Copy-boy' für die *Daily News* – "die beste Schule des Journalismus", wie er sagt.

Nach seinem Militärdienst arbeitete er ein Jahr lang für eine Tageszeitung in St Etienne, dann in Metz und begann anschließend in Paris bei seiner ersten Foto-Agentur, l'Agence Dalmas.

Drei Jahre später, 1968, wechselte er über zu Gamma, wo er heute als Redakteur beschäftigt ist.

Paul Arden. Stellvertretender Creative Direktor, Saatchi & Saatchi.

Paul Arden hat die ersten zwanzig Jahre seiner Karriere als Art Direktor verbracht und all das gelernt und getan, was man nicht tun sollte. Einschließlich fünfmaliger Kündigung.

In den letzten sechs Jahren hat er all das getan, was man tun sollte und lernt weiterhin, wie man es tut.

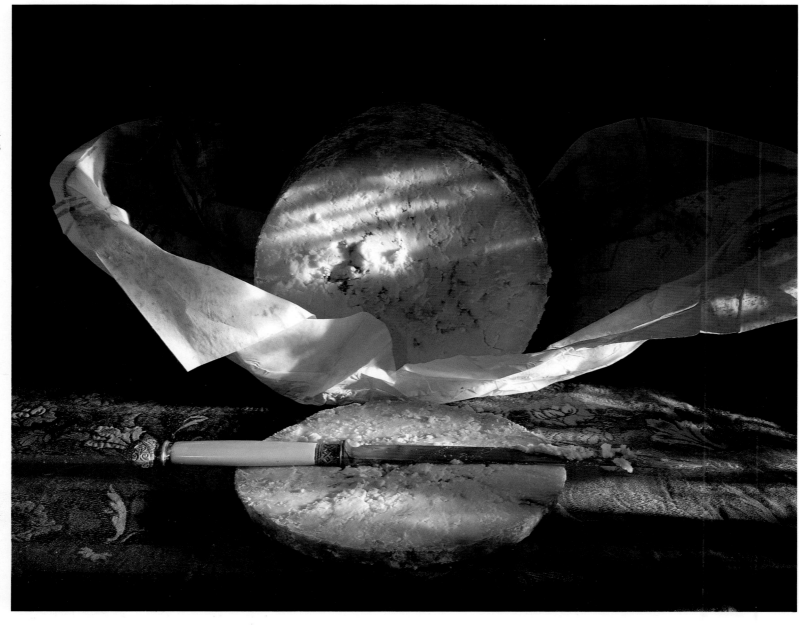

Peter Knapp
Art Director · Directeur Artistique · Art Direktor

A British Christmas.

Un Noël Britannique.

Peter Knapp
Designer · Maquettiste · Gestalter

Ein britisches Weihnachtsfest.

Patrick Kinmouth
Writer · Auteur · Autor

Decoration International December / January 1984
Publisher · Editeur · Verleger

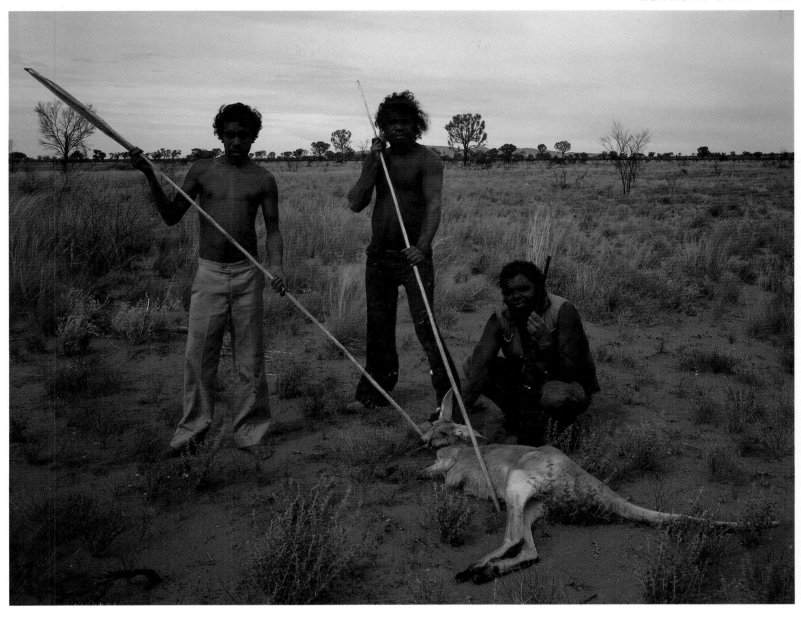

Once and Future Kings – a feature on Aborigines.

Feux et futurs rois – un article sur les Aborigènes d'Australie.

Ehemalige und zukünftige Könige – eine Reportage über
die australischen Ureinwohner.

Philip Knightley
Writer · Auteur · Autor

James Danziger
Picture Editor · Directeur de Photographie · Bildredakteur

Sunday Times Magazine
Publisher · Editeur · Verleger

2
2

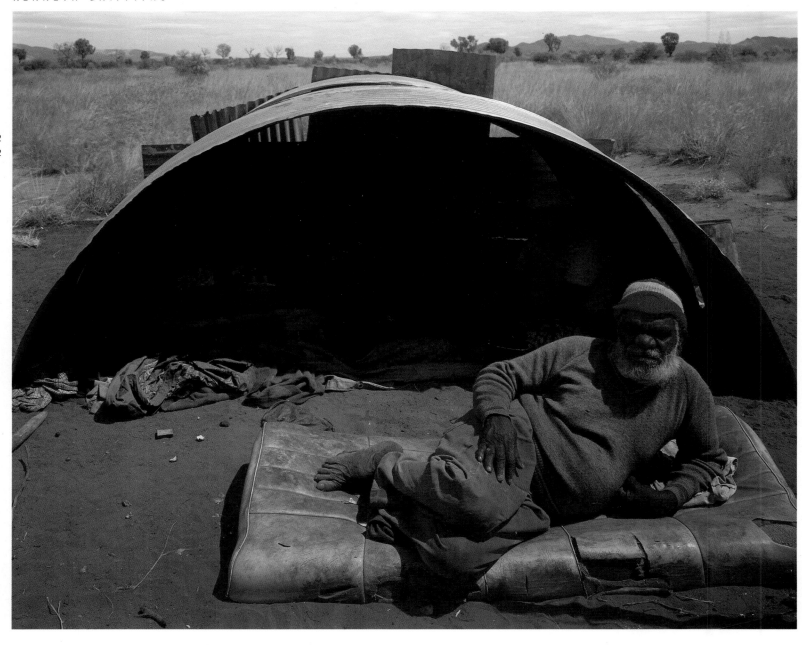

Nosepig Tjupurrala, King of the Pintubi tribe, a great ritual
leader, at Papunya, central Australia. His shelter is made
from half a water tank.

Nosepig Tjupurrula, roi du tribu Pintubi, un grand chef rituel,
à Papunya, en Australie centrale. Son abri est fabriqué
d'une moitié d'un reservoir d'eau.

Nosepig Tjupurrala, König des Pintubi Stammes, ein
bedeutender ritueller Führer, in Papunya, Zentral-Australien.
Seine Unterkunft is ein halbierter Wasserbehälter.

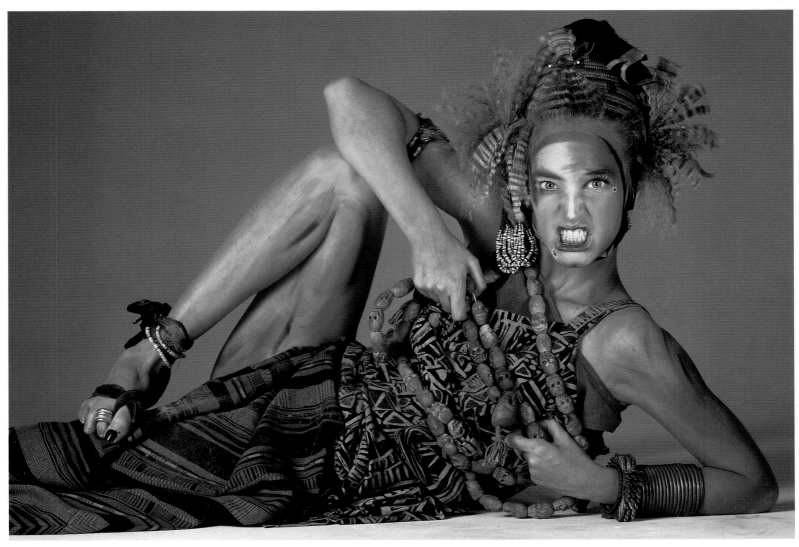

Avedon/Alexon/Africa Pages 23 to 28

Avedon/Alexon/Afrique

Avedon/Alexon/Afrika Paul Arden
Art Director · Directeur Artistique · Art Direktor

Tim Mellors
Copywriter · Redacteur · Texter

Saatchi & Saatchi
Advertising Agency · Agence Publicitaire · Werbeagentur

Alexon & Co. Limited
Client · Client · Auftraggeber

Vogue, April 1983
Publisher · Editeur · Verleger

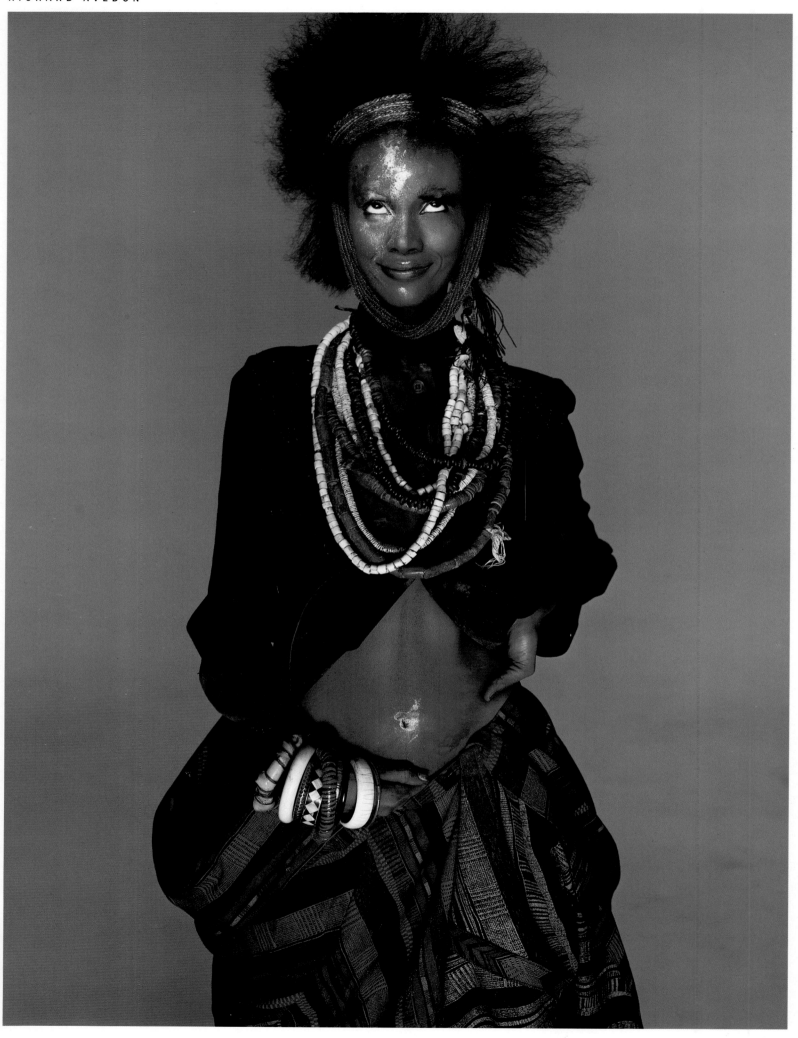

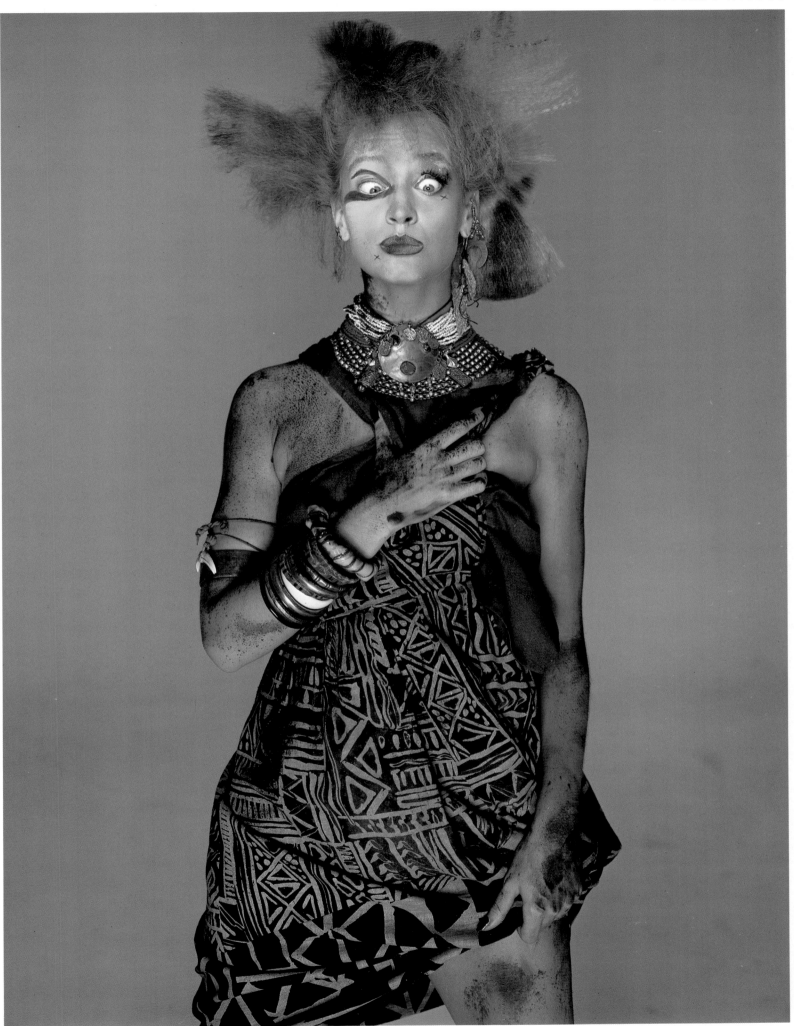

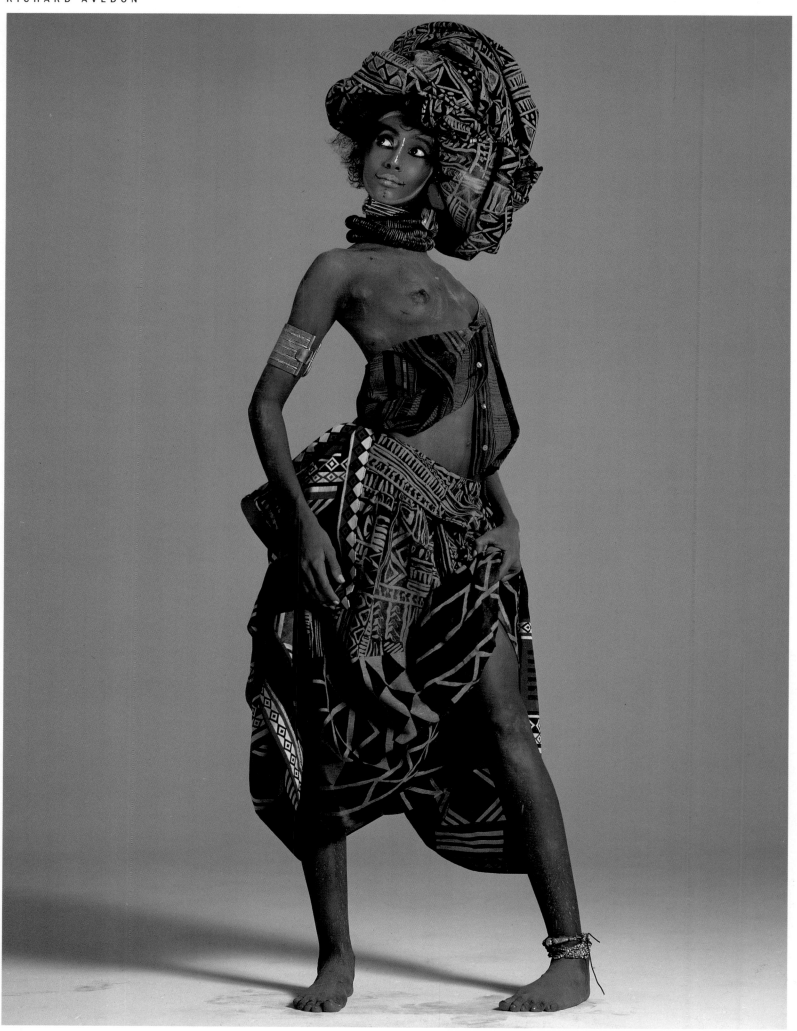

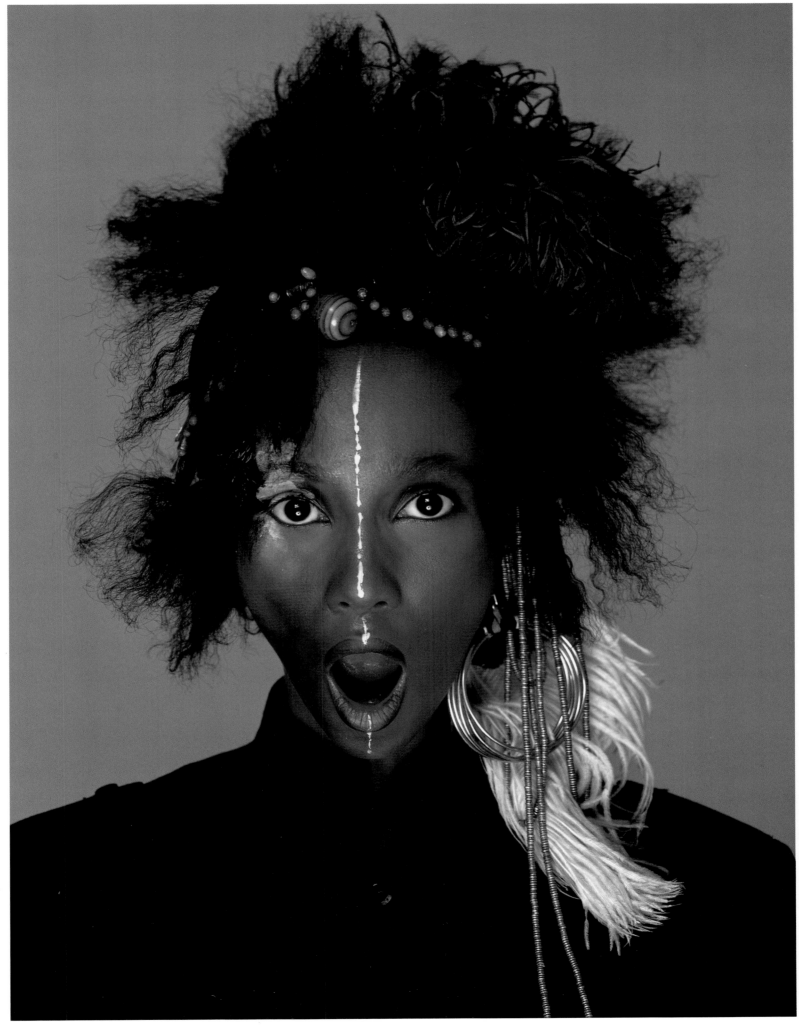

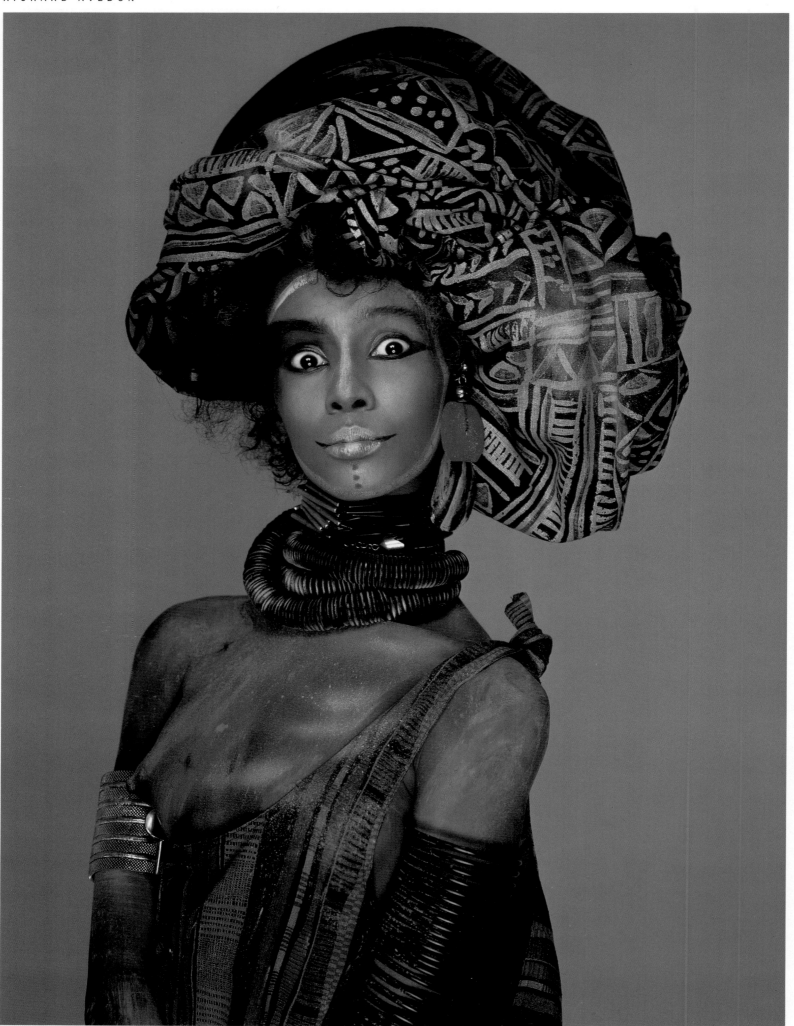

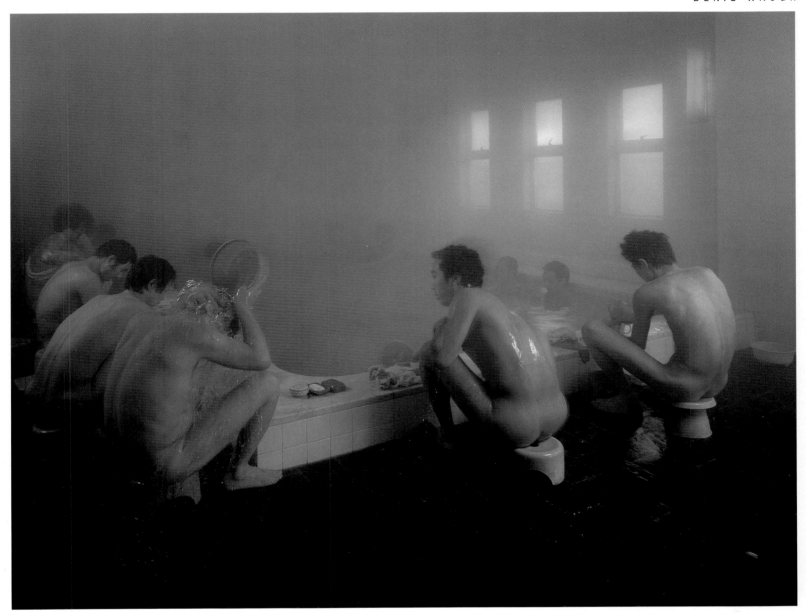

Tokyo Factory Workers Bath House. Fortune Magazine
 Publisher · Editeur · Verleger
Etablissement de bains pour les ouvriers à Tokyo.

Ein Badehaus für Arbeiter in Tokio.

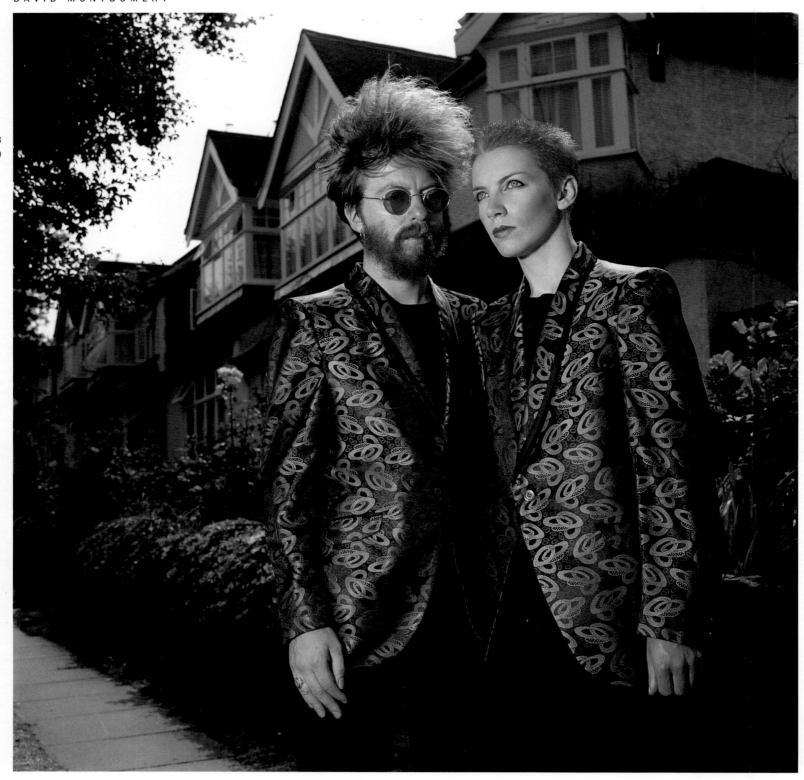

Derek Ungless
Art Director · Directeur Artistique · Art Direktor

Rolling Stone Magazine
Publisher · Editeur · Verleger

Annie Lennox and Dave Stewart.

Annie Lennox et Dave Stewart.

Annie Lennox und Dave Stewart.

Page 31

Kevin Brownlow
Writer · Auteur · Autor

James Danziger
Picture Editor · Directeur de Photographie · Bildredakteur

Sunday Times Magazine, November 1983
Publisher · Editeur · Verleger

Lilian Gish is Back.

Lilian Gish est de retour.

Lilian Gish macht einen neuen Auftritt.

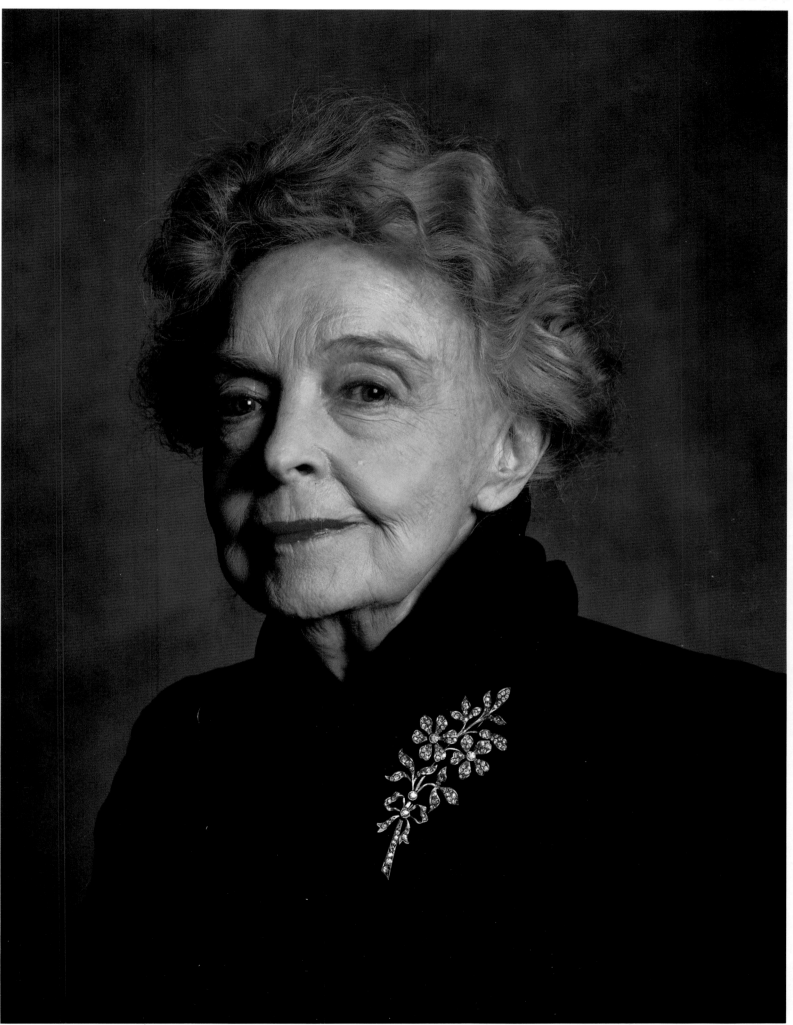

3
1

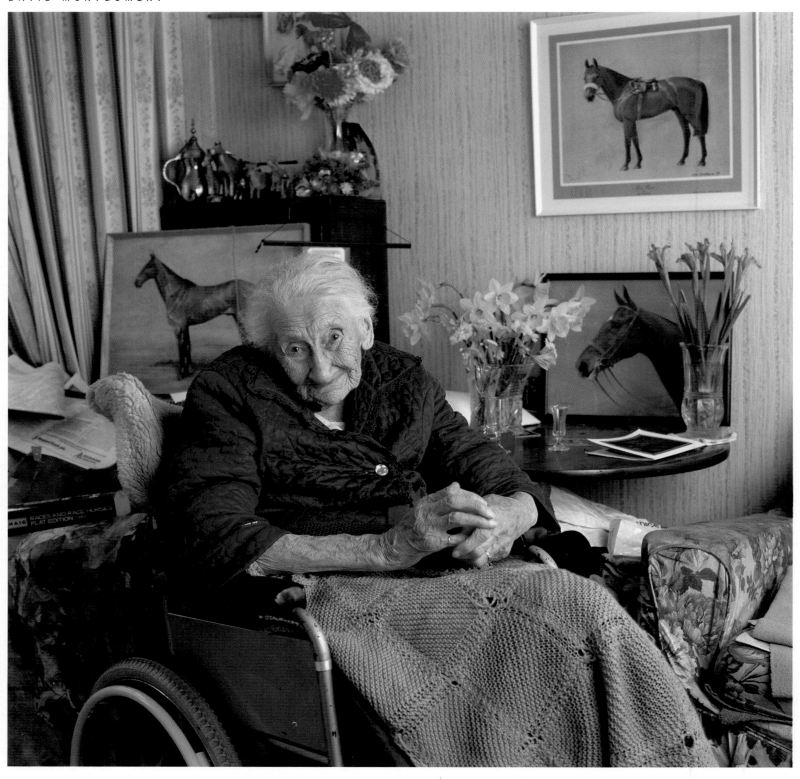

Martin Leighton
Writer · Auteur · Autor

Doris Verschoyle, 91, in her bedsitter for feature entitled:
People of Another Age.

James Danziger
Picture Editor · Directeur de Photographie · Bildredakteur

Doris Verschoyle, 91, dans son studio pour un article intitulé:
People of Another Age (Des gens d'un autre âge).

Sunday Times Magazine, July 1983
Publisher · Editeur · Verleger

Doris Verschoyle, 91, in ihrem Wohnschlafzimmer für eine
Reportage mit dem Titel: People of Another Age (Menschen
eines anderen Zeitalters).

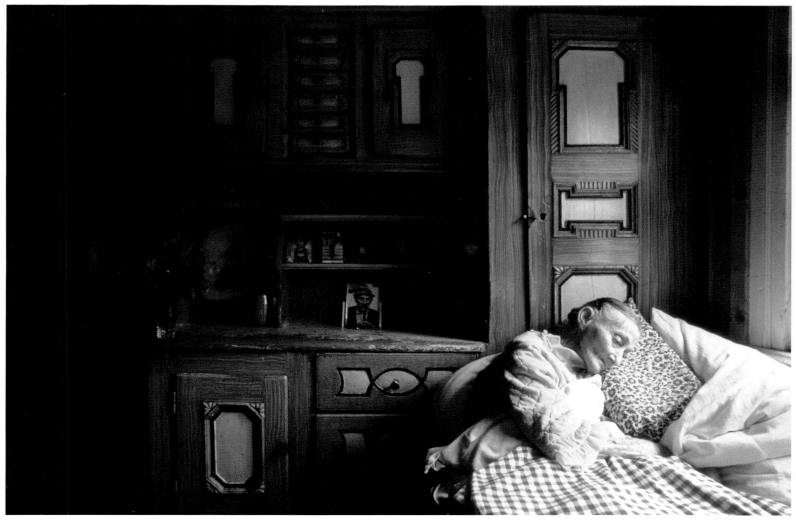

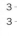

Village Life. Pages 33 to 38

Le vie des villages. Rolf Gillhausen
 Art Director · Directeur Artistique · Art Direktor

Dorfleben.

 Norbert Kleiner
 Designer · Maquettiste · Gestalter

 Stern, No. 44
 Publisher · Editeur · Verleger

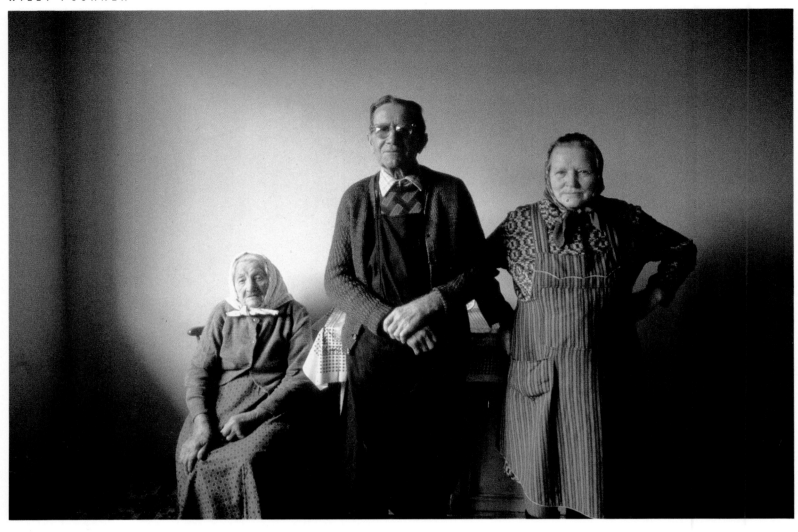

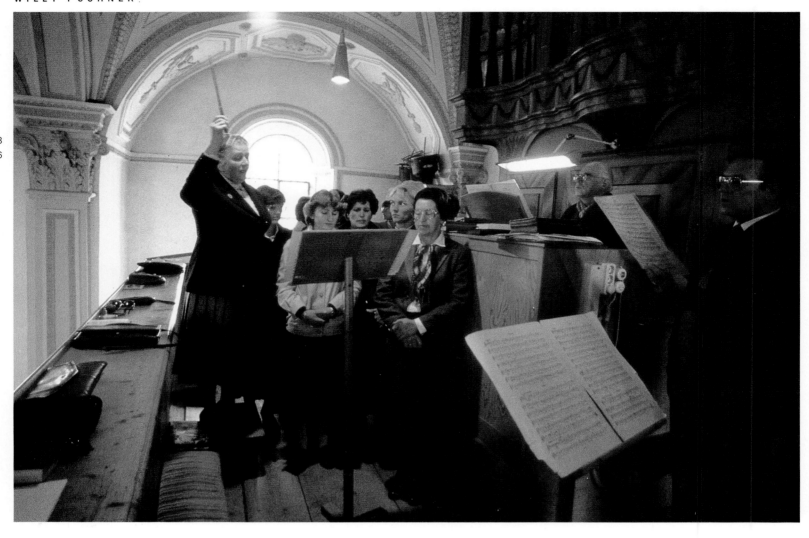

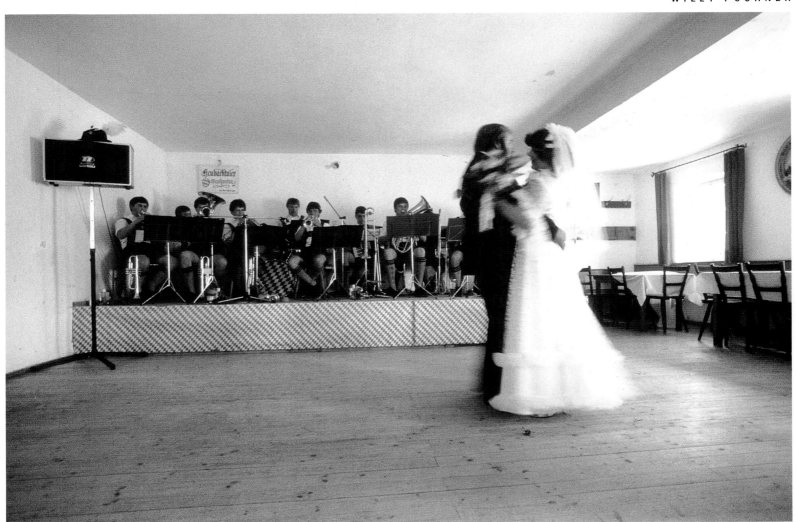

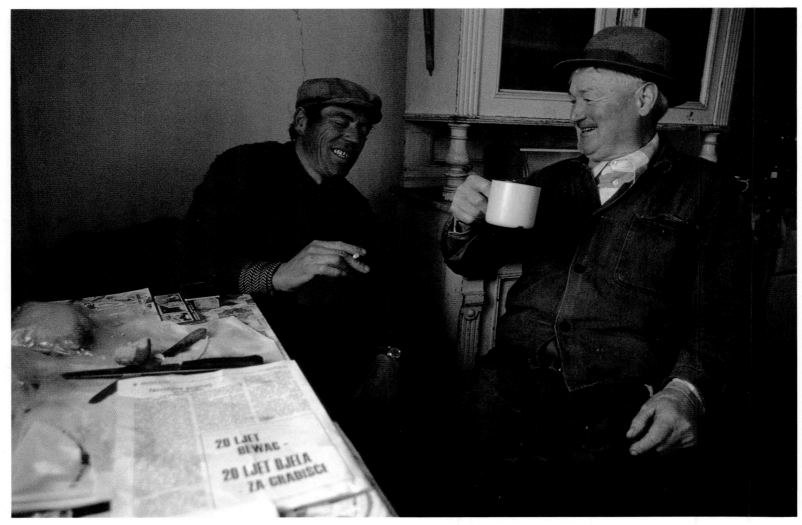

Page 39 Cleveland, Wisconsin: Farmer
From her book: Eve Arnold in America.

Eve Arnold
Writer · Auteur · Autor Cleveland, Wisconsin: Agriculteur
Extrait de son livre: Eve Arnold in America (Eve Arnold aux
Etats-Unis).

James Danziger
Picture Editor · Directeur de Photographie · Bildredakteur

Cleveland, Wisconsin: Landwirt
Sunday Times Magazine Aus ihrem Buch: Eve Arnold in America (Eve Arnold in
Publisher · Editeur · Verleger Amerika).

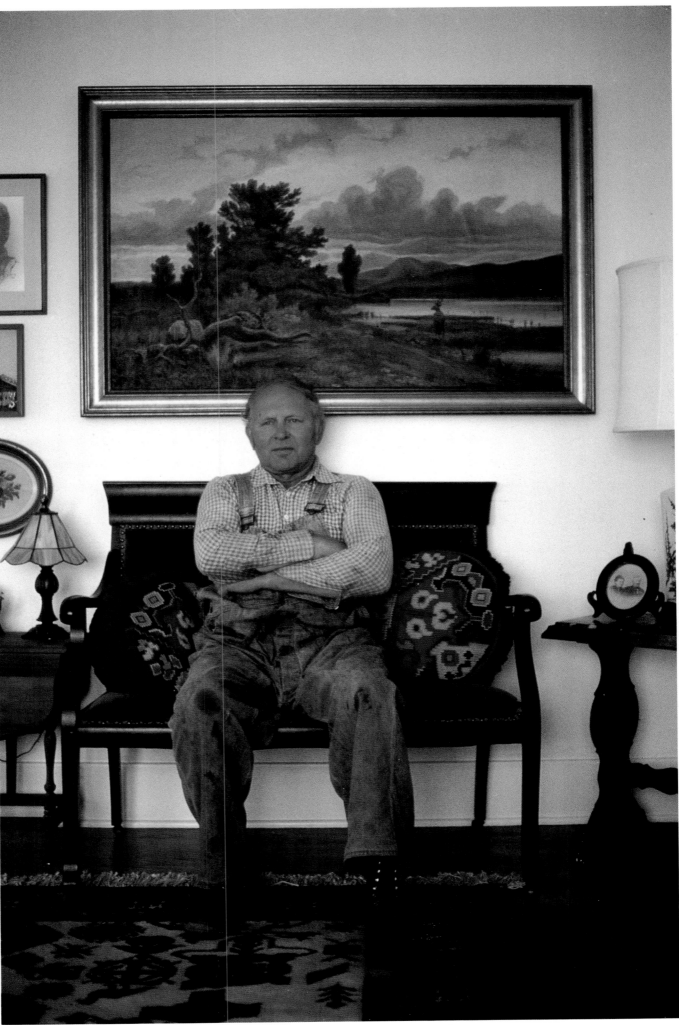

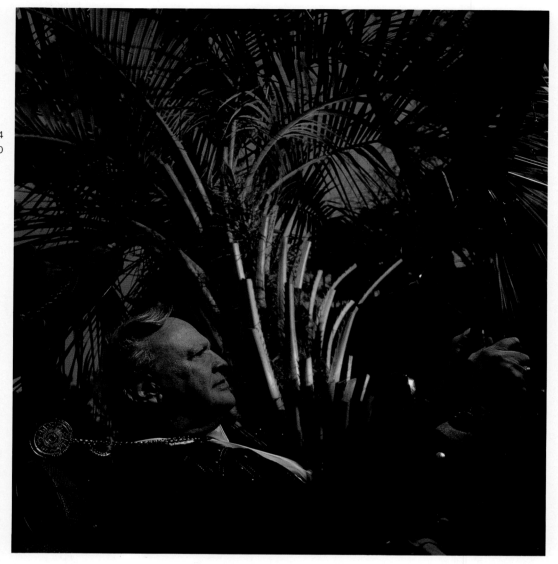

Robert Priest
Art Director · Directeur Artistique · Art Direktor

April Silver
Designer · Maquettiste · Gestalter

James Dickey
Writer · Auteur · Autor

Jennifer Crandall
Picture Editor · Directeur de Photographie · Bildredakteur

Esquire Magazine
Publisher · Editeur · Verleger

The Poetics of Dress. James Dickey in his car at his home in S. Carolina, USA.

La poétique de l'habillement. James Dickey dans sa voiture chez lui en Caroline de Sud, USA.

Die Poesie der Bekleidung. James Dickey in seinem Wagen bei seinem Haus in Süd-Carolina, USA.

Page 41

April Silver
Art Director · Directeur Artistique · Art Direktor

John Miller
Designer · Maquettiste · Gestalter

John Mather
Writer · Auteur · Autor

Jennifer Crandall
Picture Editor · Directeur de Photographie · Bildredakteur

Esquire Magazine
Publisher · Editeur · Verleger

American Pops. Tom Evert, a dancer with the Paul Tyler Dance Company, and his one-year-old son.

American Pops. Tom Evert, danseur de la Compagnie Paul Tyler, avec son fils âgé d'un an.

American Pops. Tom Evert, ein Tänzer der Paul Tyler Tanzgruppe, mit seinem einjährigen Sohn.

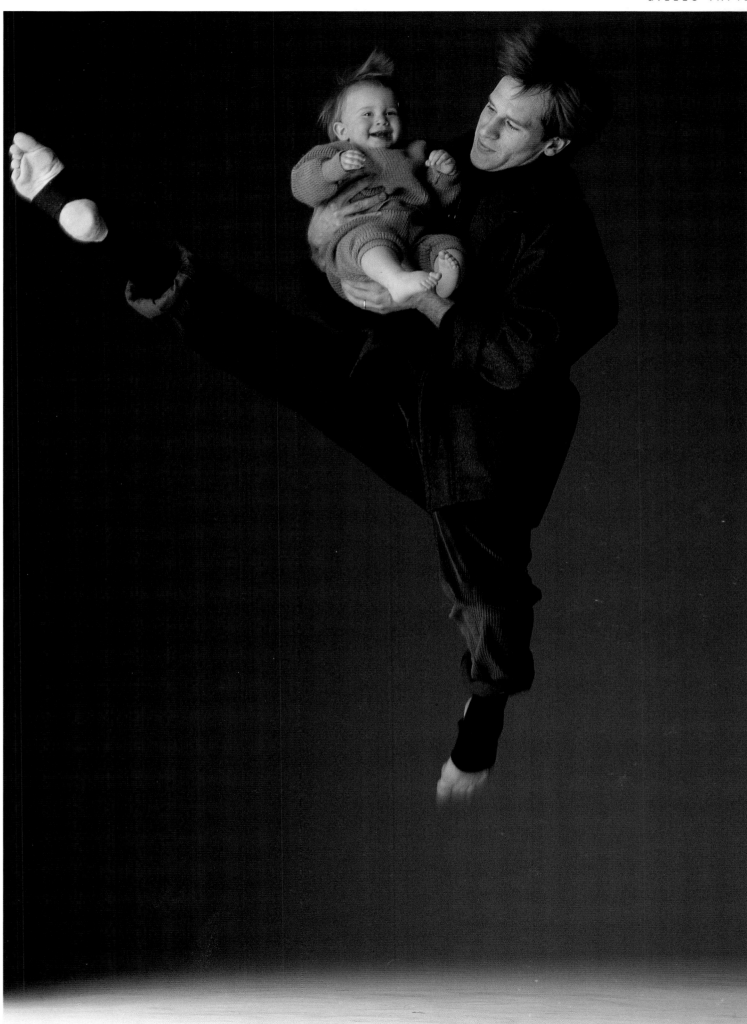

4
2

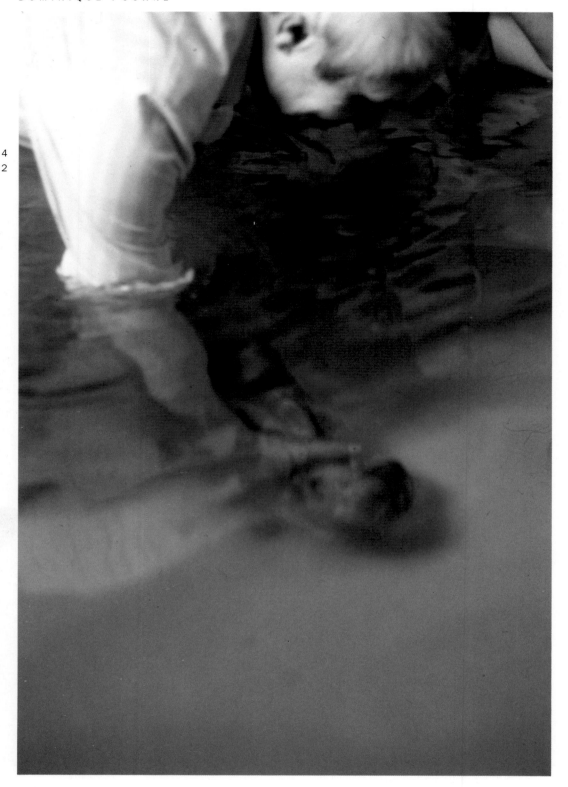

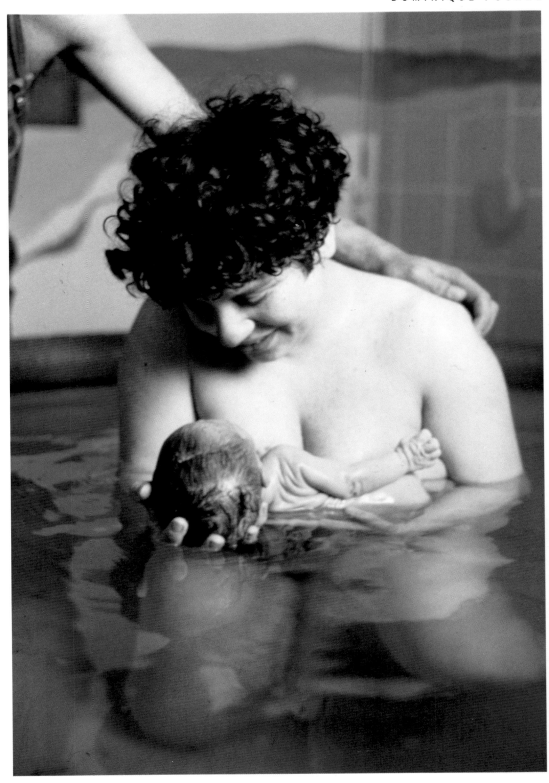

First moments of the relationship between mother and
child.

Premiers moments de la relation entre la mère et l'enfant.

Die ersten Momente der Beziehung zwischen Mutter und
Kind.

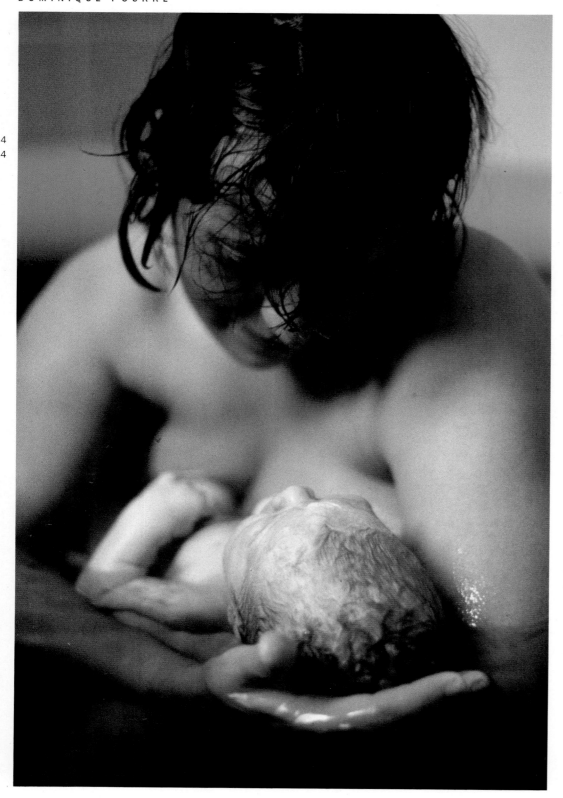

4
4

Mother and baby moments after an underwater delivery.

Mère et enfant quelques instants après un accouchement sous l'eau.

Mutter und Kind kurz nach einer Unterwasser-Geburt.

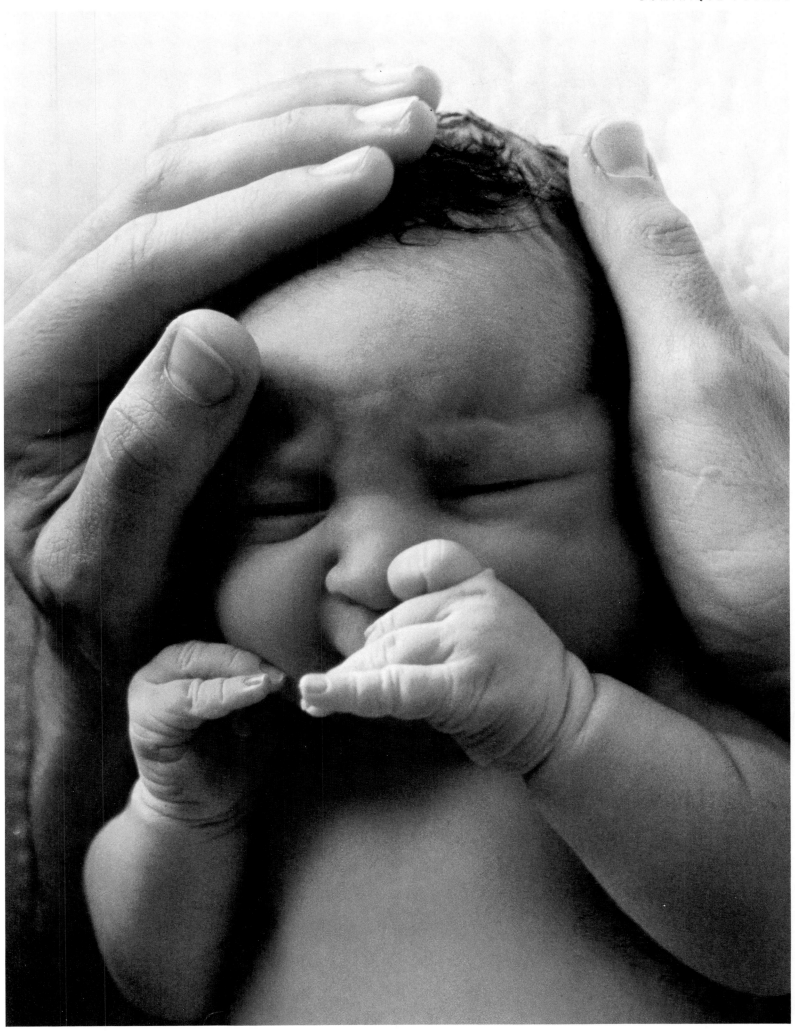

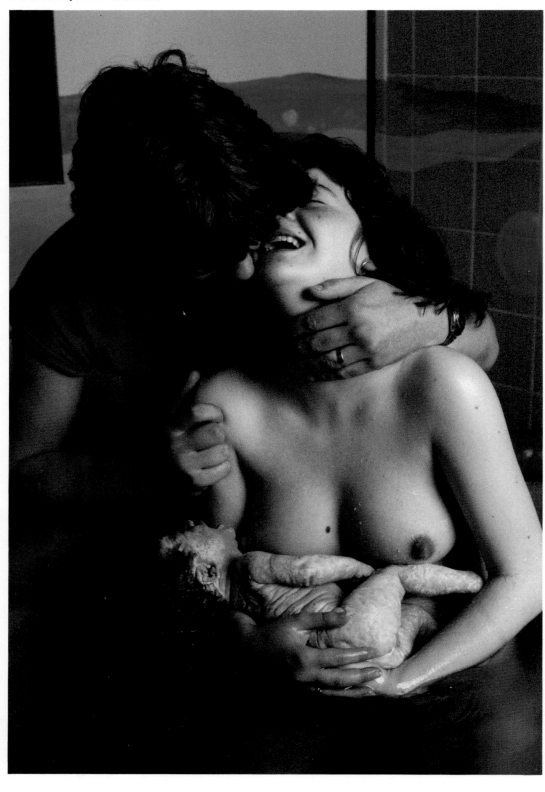

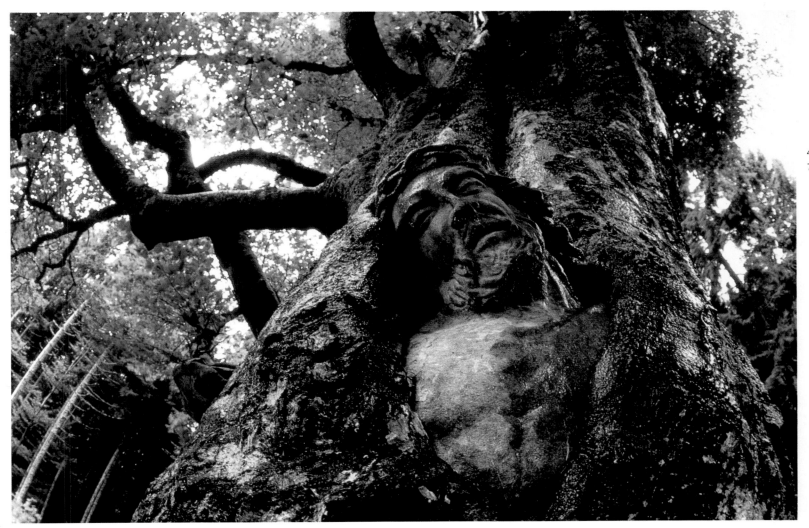

The tree. Pages 47 to 49

L'arbre. Rolf Gillhausen
 Art Director · Directeur Artistique · Art Direktor

Der Baum.

 Stern, No. 38
 Publisher · Editeur · Verleger

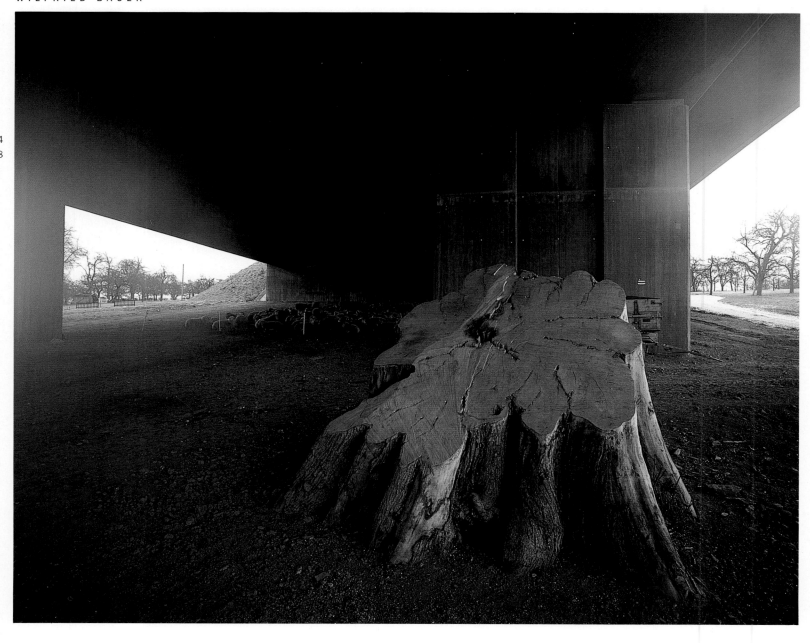

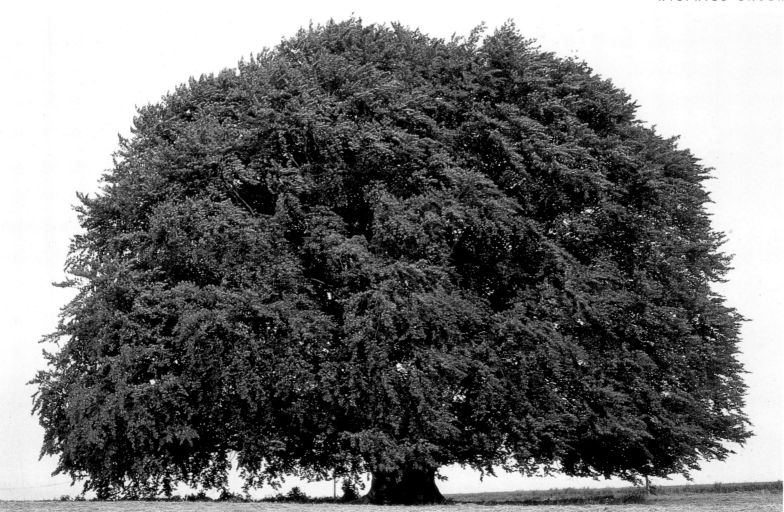

5
0

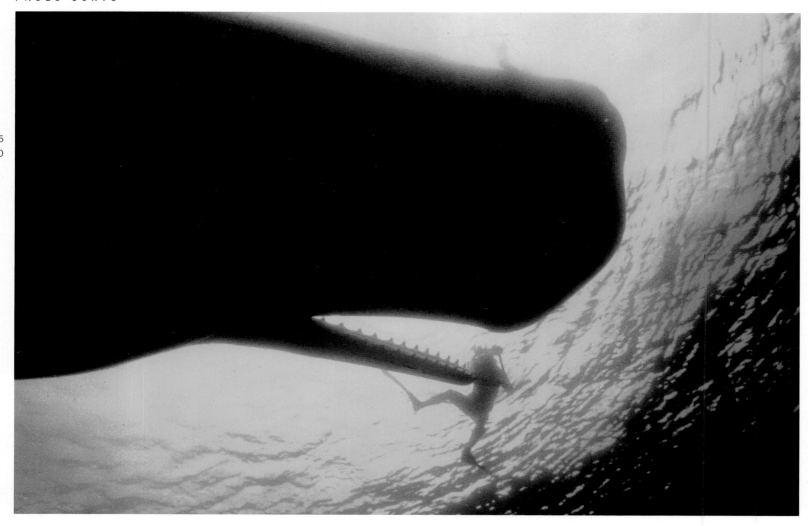

Wolfgang Behnken
Art Director · Directeur Artistique · Art Direktor

Franz Epping
Designer · Maquettiste · Gestalter

Stern, No. 23
Publisher · Editeur · Verleger

Party with a whale.

La fête avec une baleine.

Wal-Party.

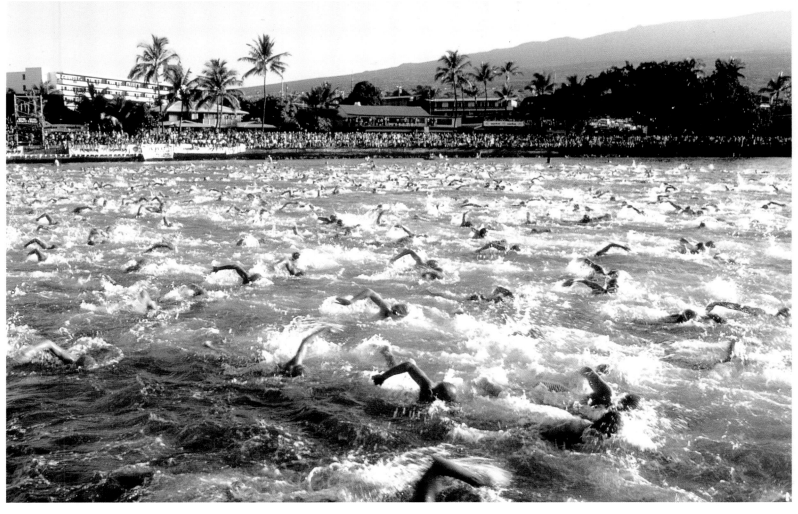

Three times through hell. Rolf Gillhausen
 Art Director · Directeur Artistique · Art Direktor

Trois fois à travers l'enfer.

Dreimal durch die Hölle. Detlef Schlottmann
 Designer · Maquettiste · Gestalter

Stern, No. 46
Publisher · Editeur · Verleger

Pages 52, 53 The Eighth World Wonder.

Rolf Gillhausen La huitième merveille du monde.
Art Director · Directeur Artistique · Art Direktor

 Das achte Weltwunder.

Otto Reinecke
Designer · Maquettiste · Gestalter

Stern, No. 43
Publisher · Editeur · Verleger

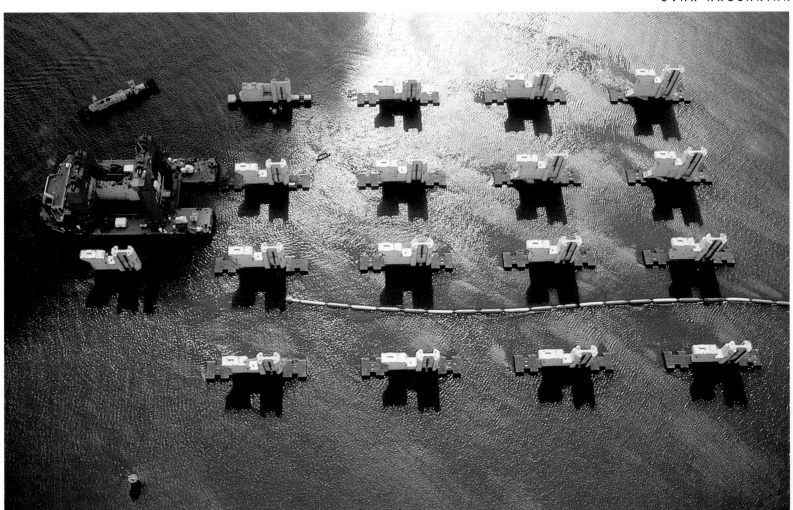

5
3

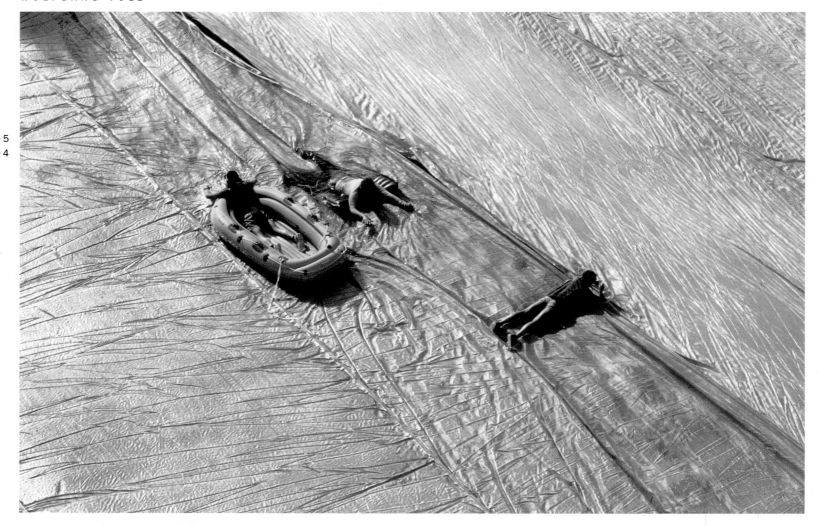

Pages 54 to 57 Christo with a Pink Tutu.

Rolf Gillhausen Christo avec un tutu rose.
Art Director · Directeur Artistique · Art Direktor

 Christo mit rosa Tütü.

Dieter Busch
Designer · Maquettiste · Gestalter

Stern, No. 21
Publisher · Editeur · Verleger

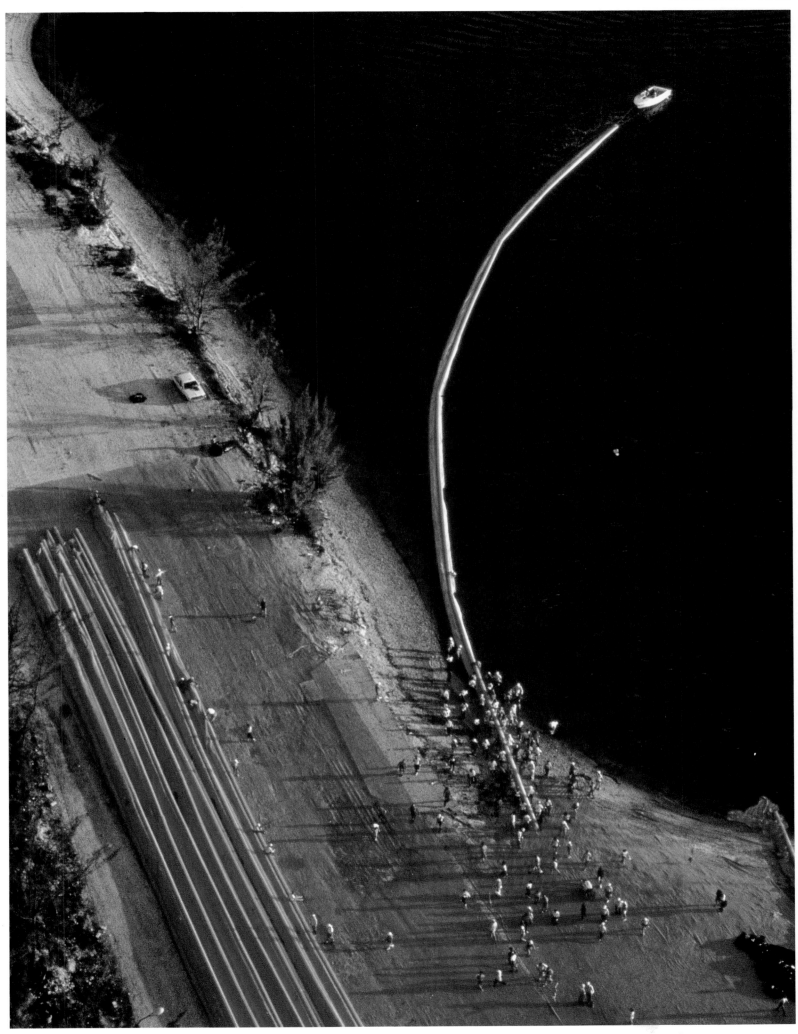

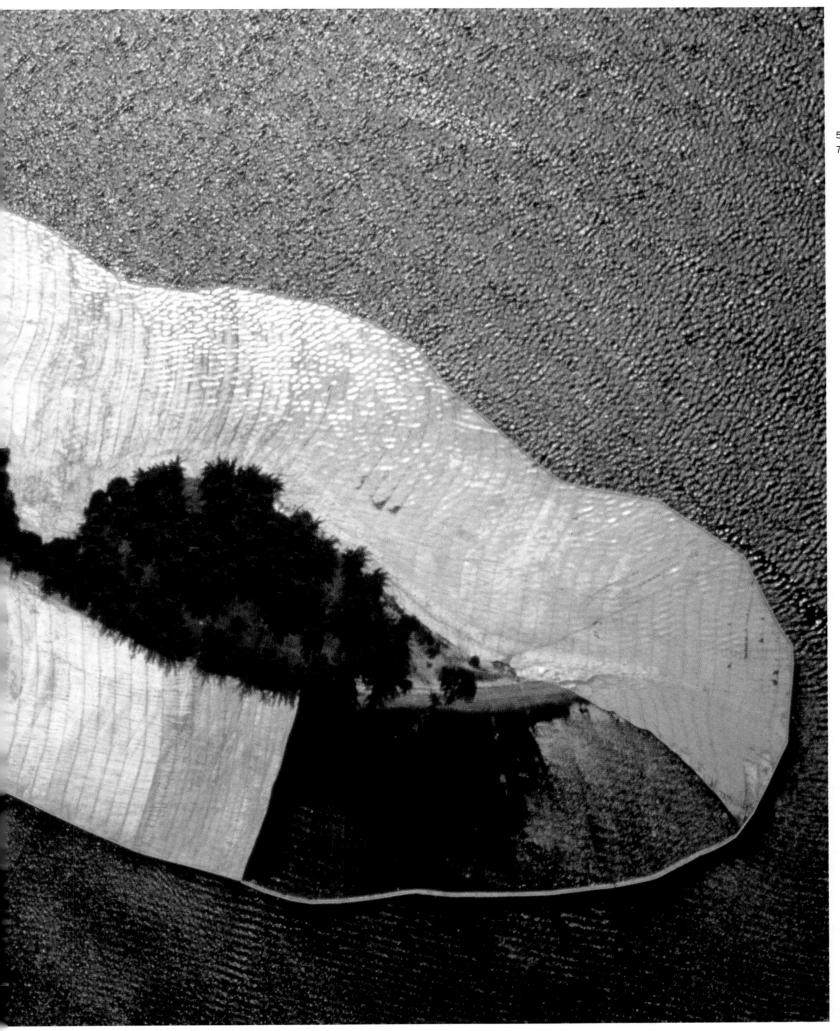

Pages 58, 59 Beirut.

Wolf Gillhausen Beyrouth.
Art Director · Directeur Artistique · Art Direktor
Beirut.

Herbert Suhr
Designer · Maquettiste · Gestalter

Stern, No. 32
Publisher · Editeur · Verleger

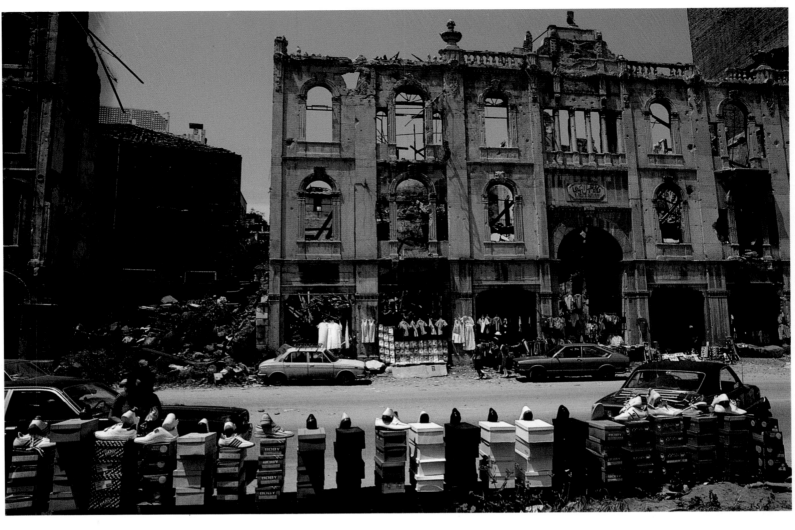

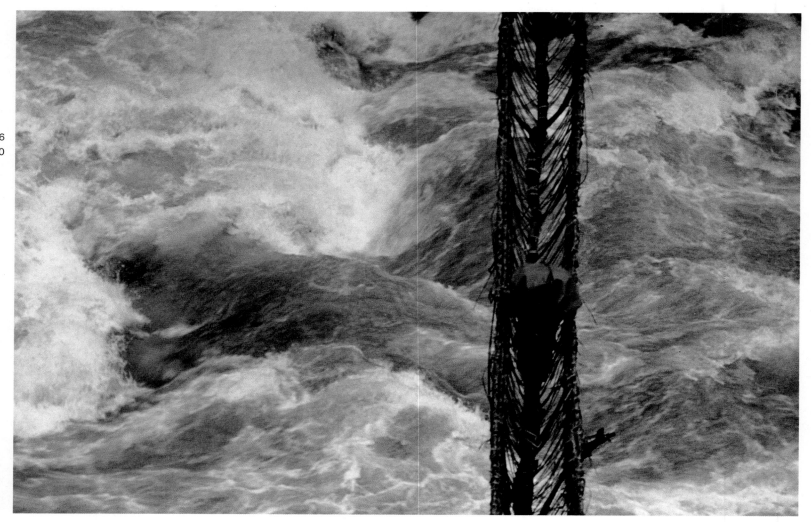

Pages 60 to 64 For a few sacks of flour.

Wolfgang Behnken Pour quelques sacs de farine.
Art Director · Directeur Artistique · Art Direktor

Für ein paar Säcke Mehl.

Günther Meyer
Designer · Maquettiste · Gestalter

Stern, No. 9
Publisher · Editeur · Verleger

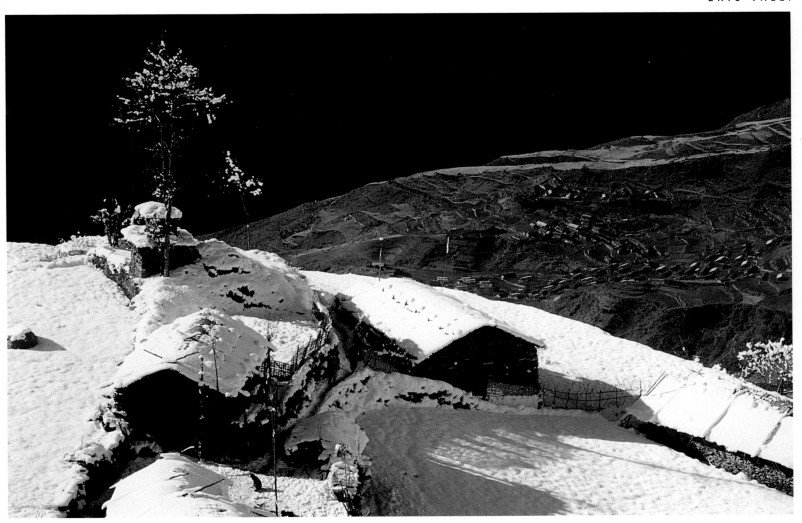

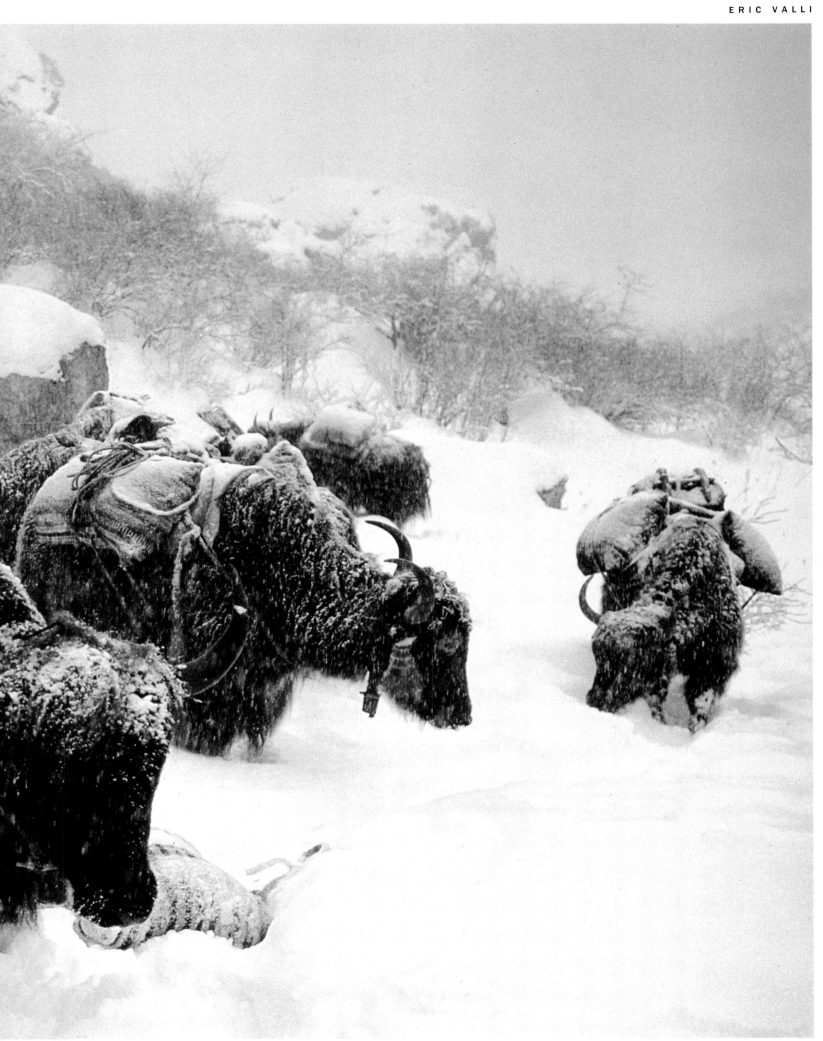

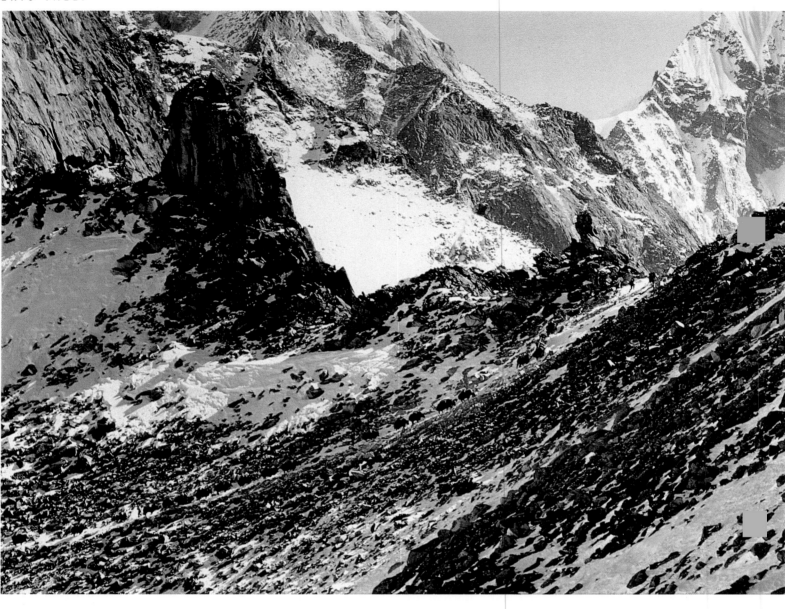

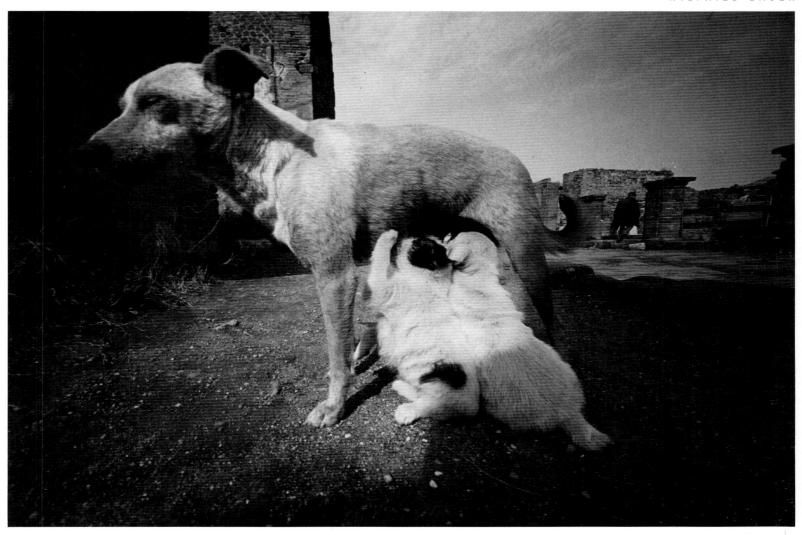

Naples. Stern
 Publisher · Editeur · Verleger
Naples.

Neapel.

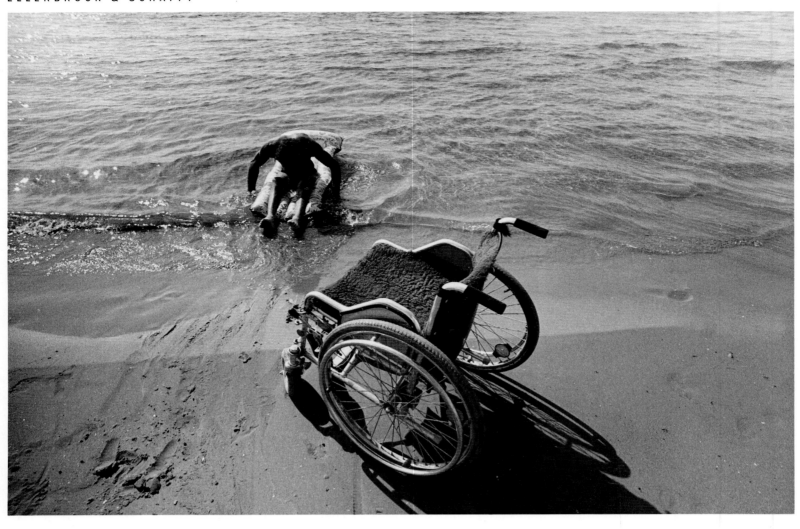

6
6

Pages 66 to 69 · Wheelchair.

Stern Fauteuil roulant.
Publisher · Editeur · Verleger

Rollstuhl.

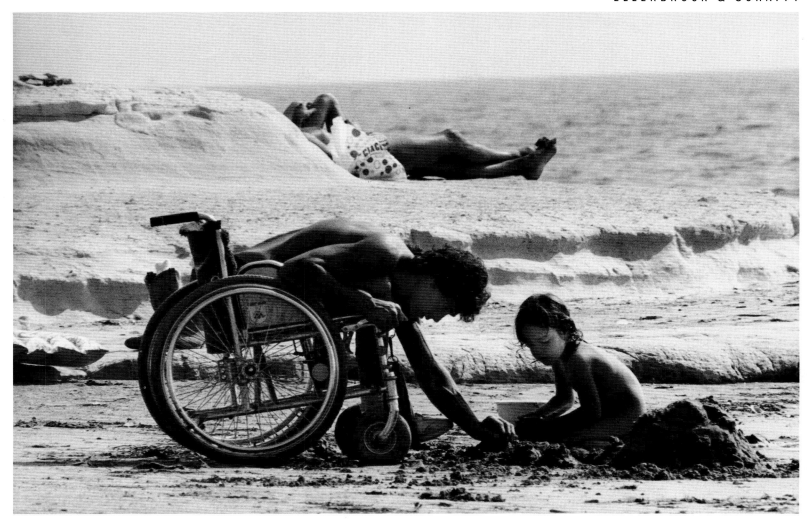

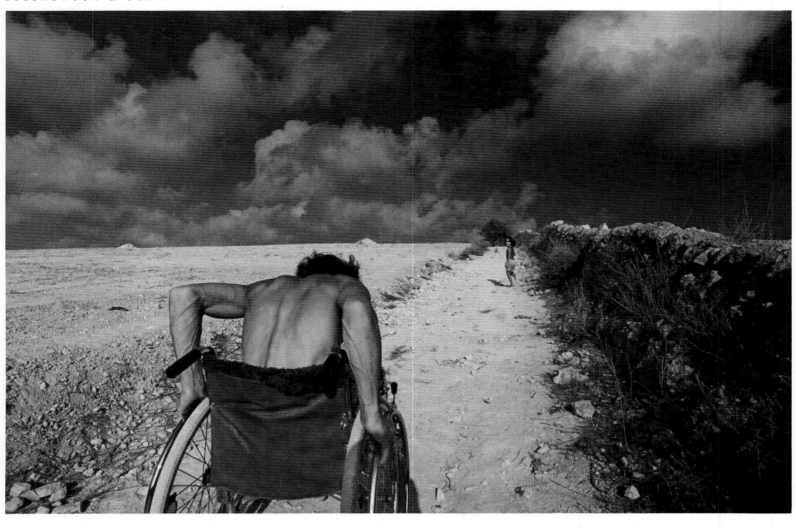

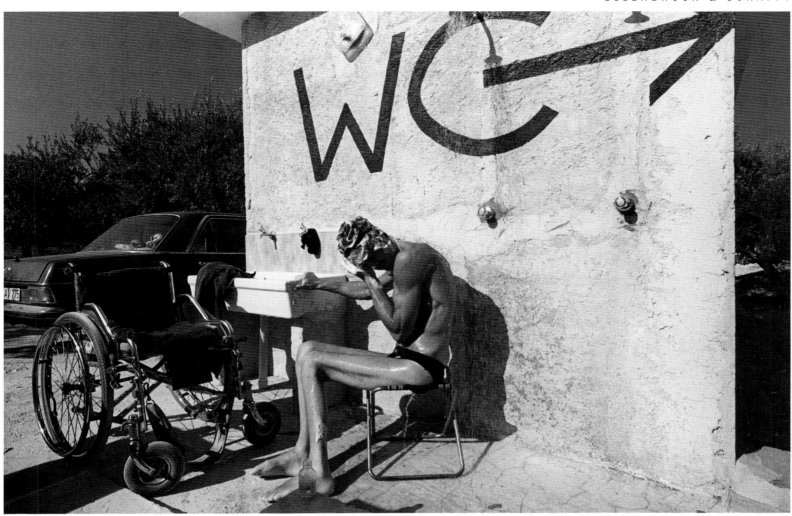

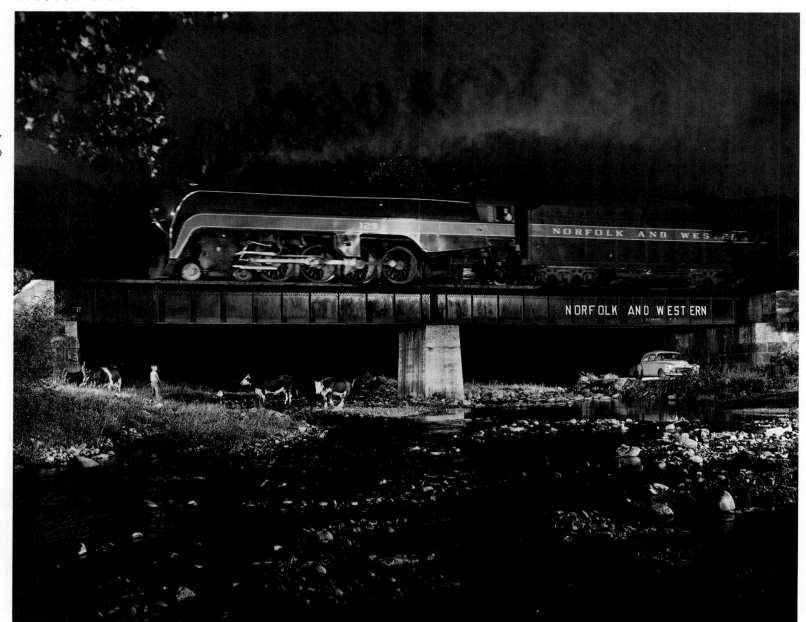

Pages 70, 71 Simultaneous opposite views, Arcadia, Va., 1956.

James Danziger Vues simultanées opposées, Arcadia, Va., 1956.
Picture Editor · Directeur de Photographie · Bildredakteur

Sunday Times Magazine, June 1983 Gleichzeitige, entgegengesetzte Beobachtungen, Arcadia,
Publisher · Editeur · Verleger Va., 1956.

Pages 72, 73 Night Trains.

Trains de nuit.

Nachtzüge.

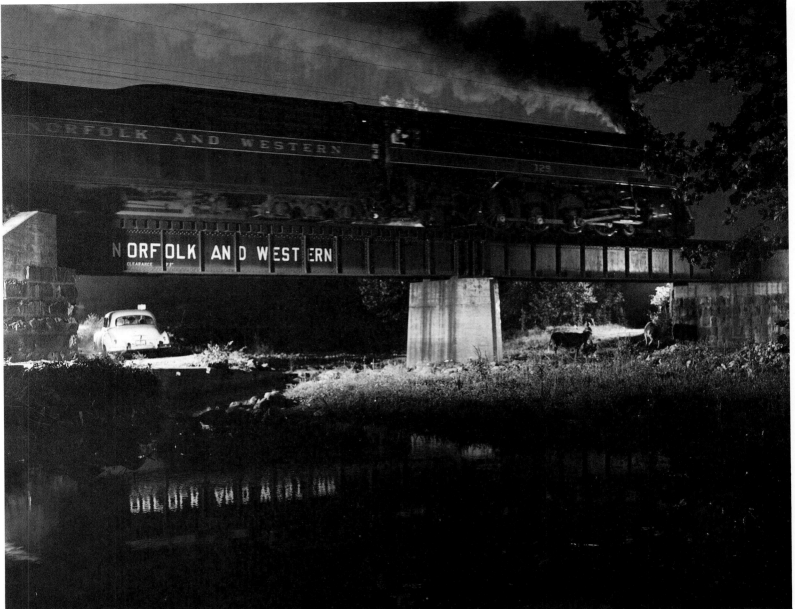

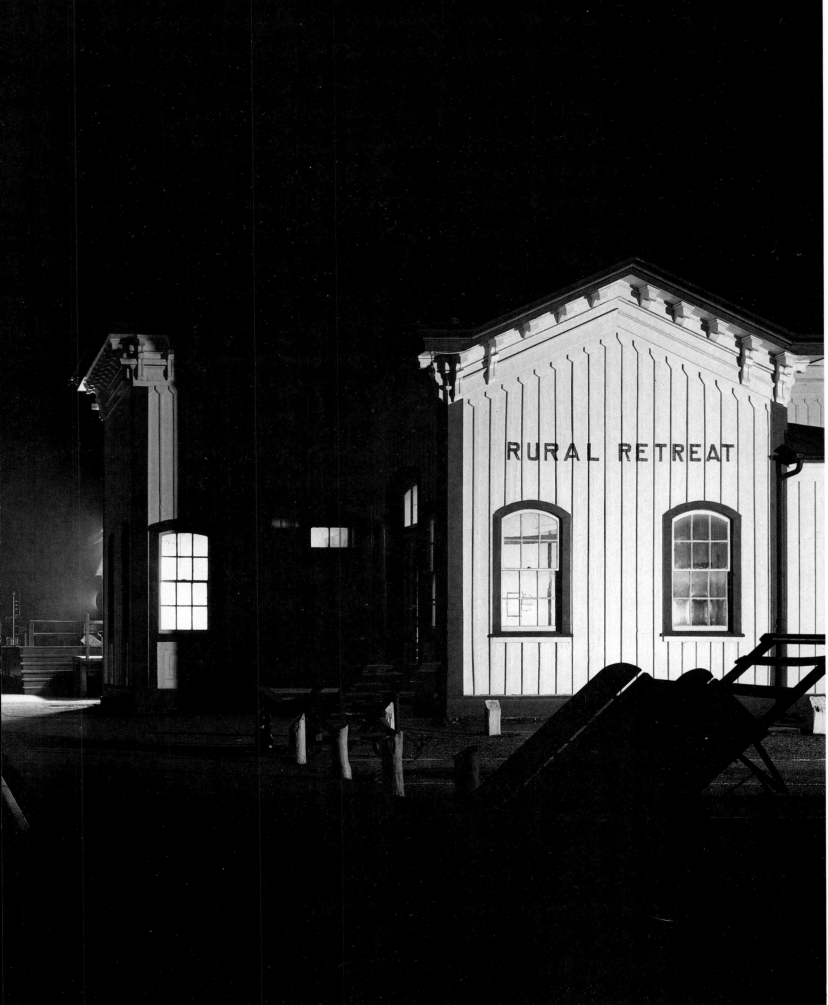

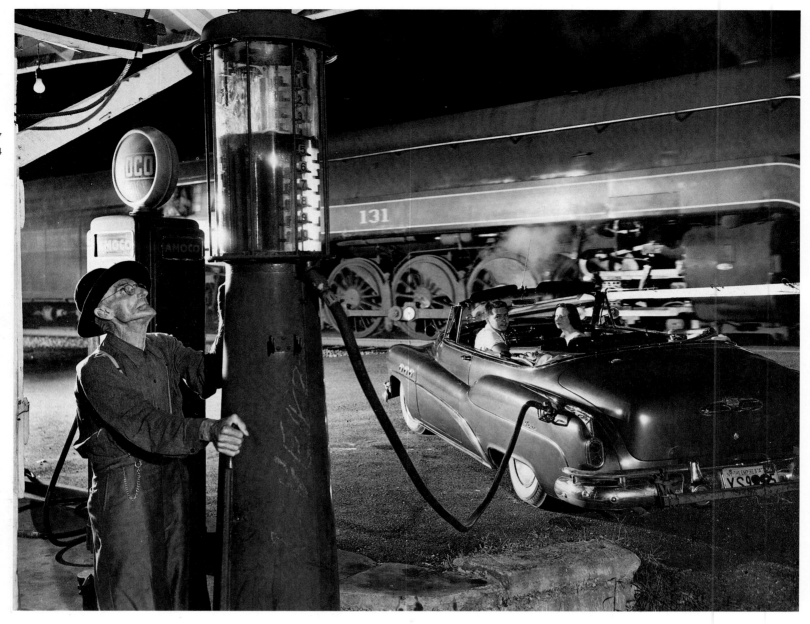

Sometimes the electricity fails, 1956.

Parfois il y a une panne d'éléctricité.

Manchmal fällt der Strom aus, 1956.

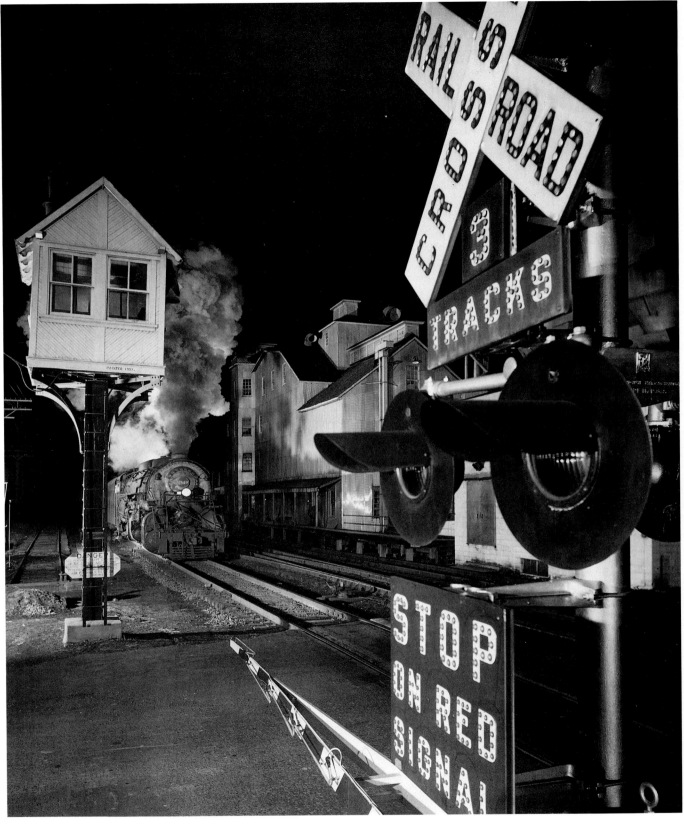

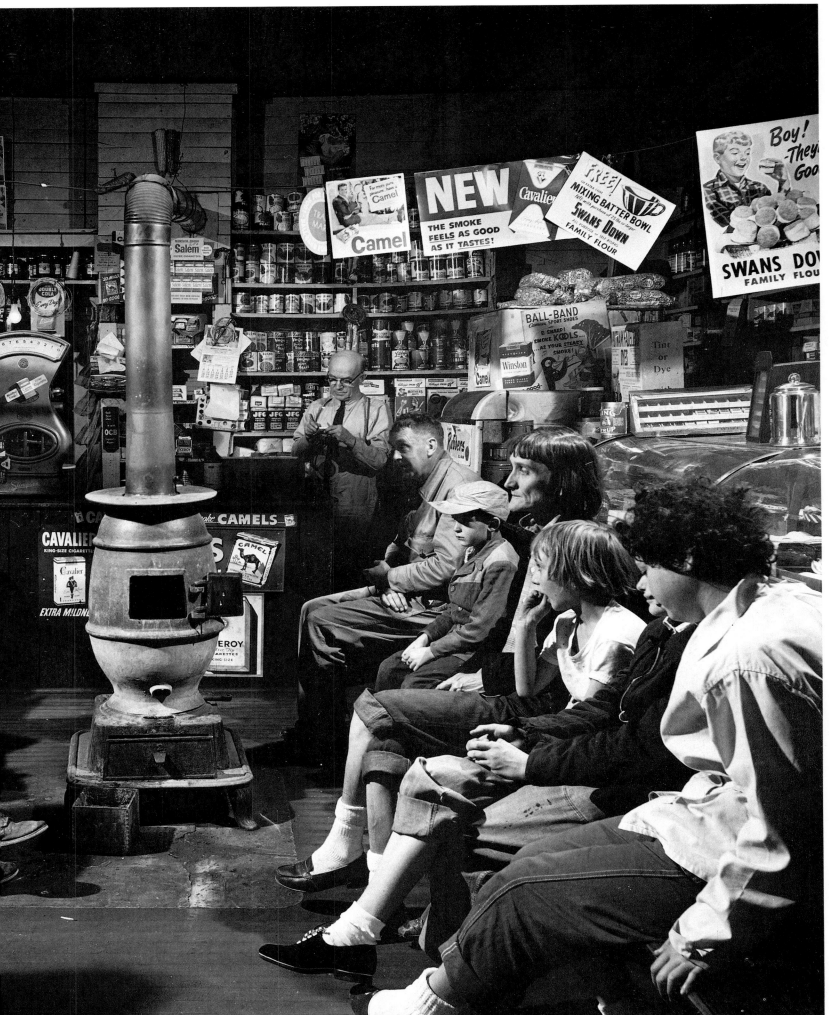

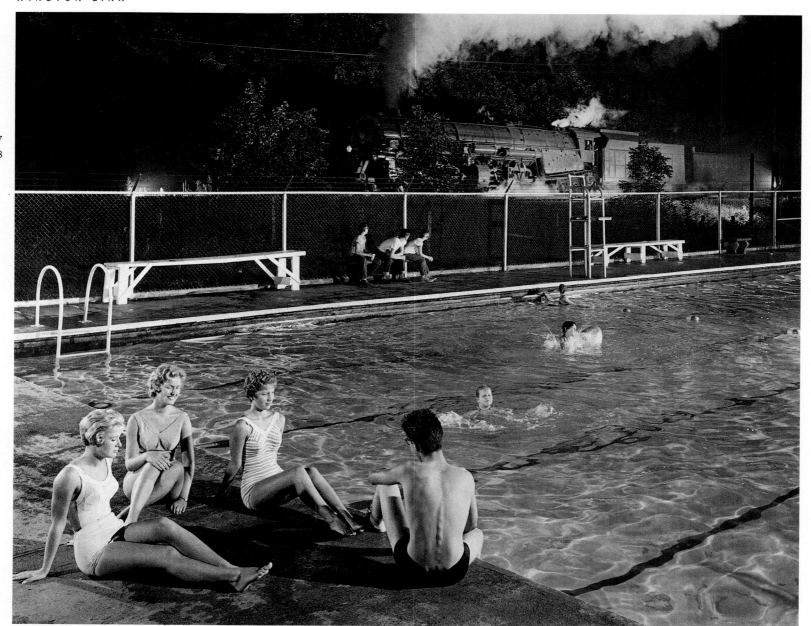

Swimming Pool at Welch, 1958.

Piscine à Welch, 1958.

Schwimmbad in Welch, 1958.

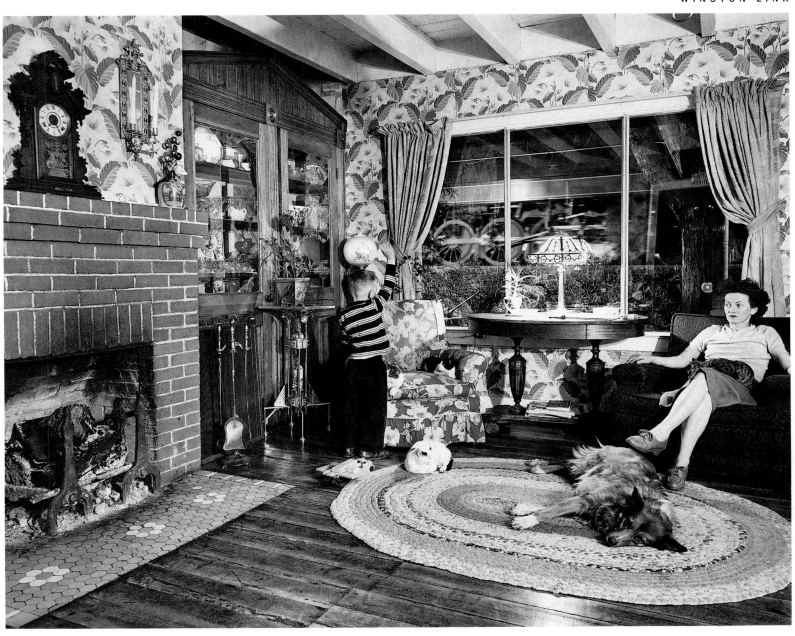

Living Room on the Tracks, 1955.

Salle de séjour sur la voie, 1955.

Wohnzimmer auf den Schienen, 1955.

Wolfgang Behnken France.
Art Director · Directeur Artistique · Art Direktor

 La France.
Stern, No. 25
Publisher · Editeur · Verleger Frankreich.

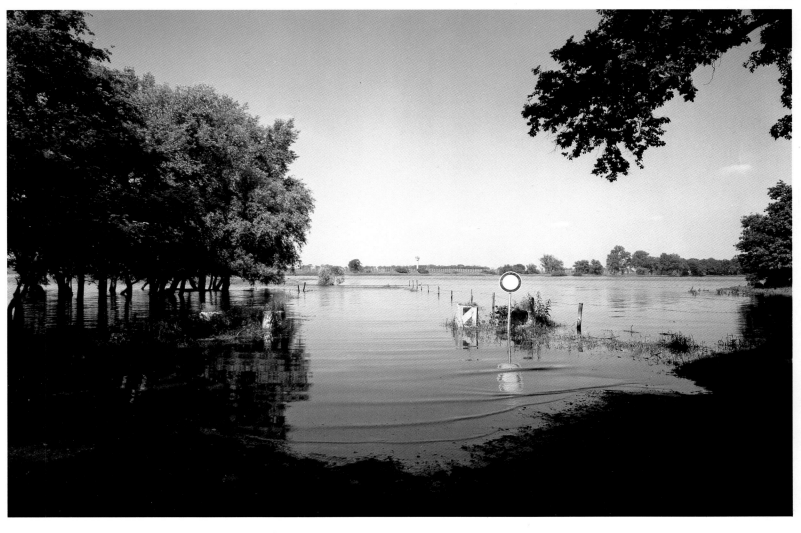

Just short of the pain-barrier. Pages 81 to 83

Juste en dessous du mur de douleur. Wolfgang Behnken
 Art Director · Directeur Artistique · Art Direktor

Kurz vor der Schmerz-Grenze. Karl-Heinz John
 Designer · Maquettiste · Gestalter

 Stern, No. 30
 Publisher · Editeur · Verleger

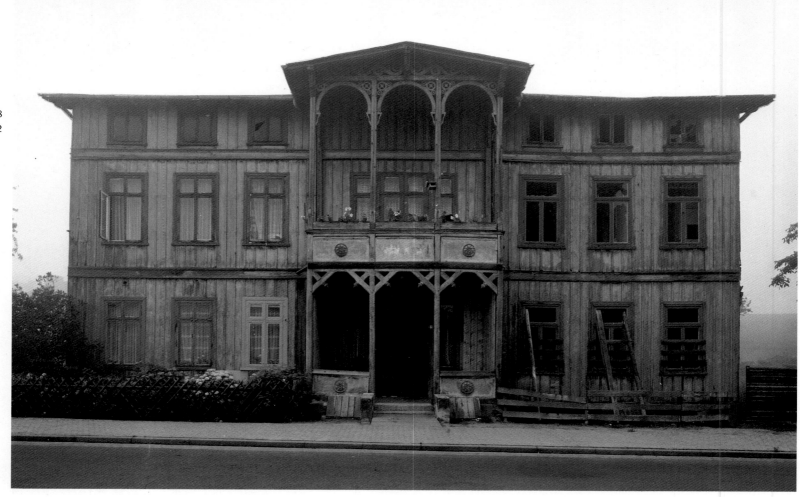

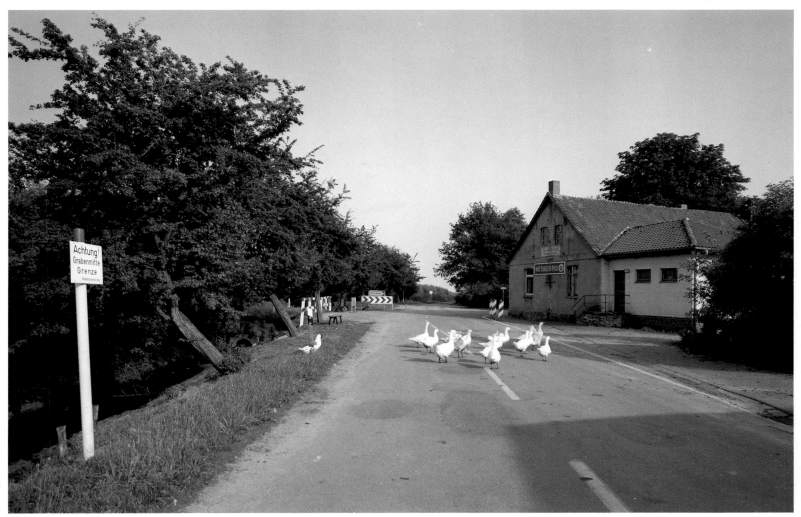

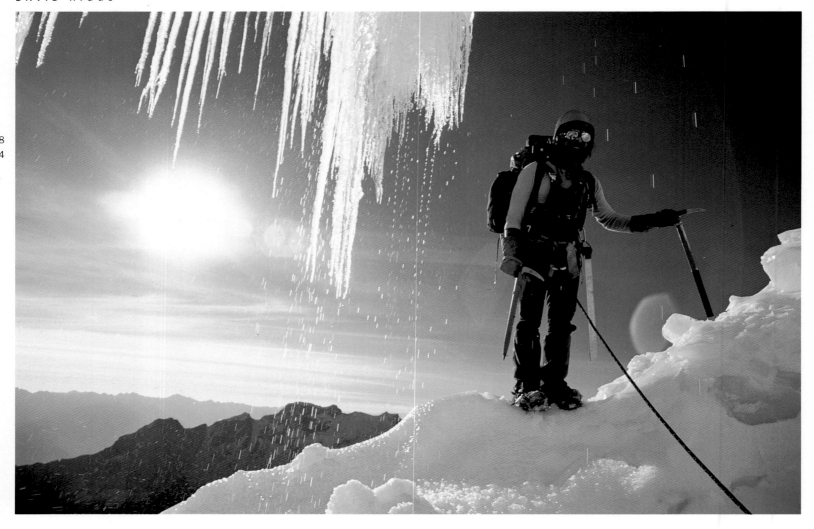

June Stanier
Art Director · Directeur Artistique · Art Direktor

Graham Jones
Writer · Auteur · Autor

Cavenham Communications Ltd, Now Magazine
Publisher · Editeur · Verleger

Cruel Peaks of Beauty – Nevada Huandoy, Cordillera Blanca,
Peru. Also published in David Higgs' book: 'Mountain
Photography,' Longman 1983.

Belles cimes cruelles – Nevada Huandoy, Cordillera Blanca,
Peru. Publié aussi dans le livre de David Higgs: 'Mountain
Photography,' Longman 1983.

Grausame, schöne Berge – Nevada Huandoy, Cordillera
Blanca, Peru. Außerdem erschienen in David Higgs Buch:
'Mountain Photography,' Longman 1983.

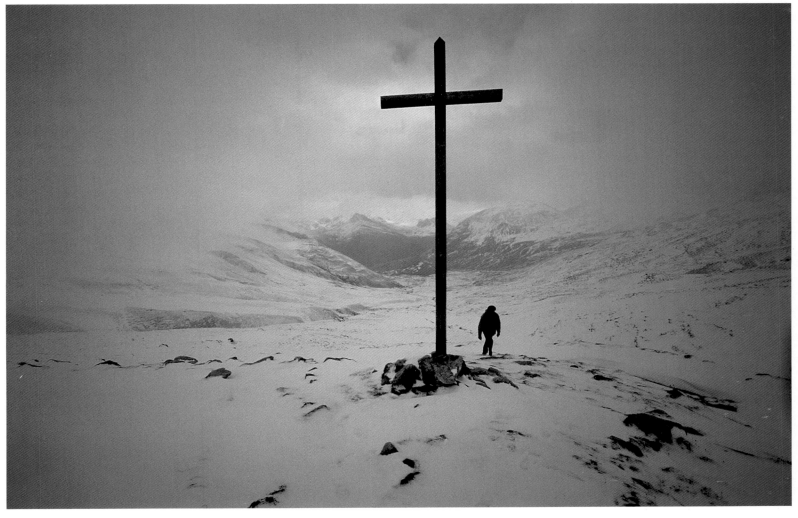

To Rome, with Luther. Pages 85 to 89

A Rome, avec Luther. Rolf Gillhausen
 Art Director · Directeur Artistique · Art Direktor

Mit Luther Nach Rom.

Walter Strenge
Designer · Maquettiste · Gestalter

Stern, No. 12
Publisher · Editeur · Verleger

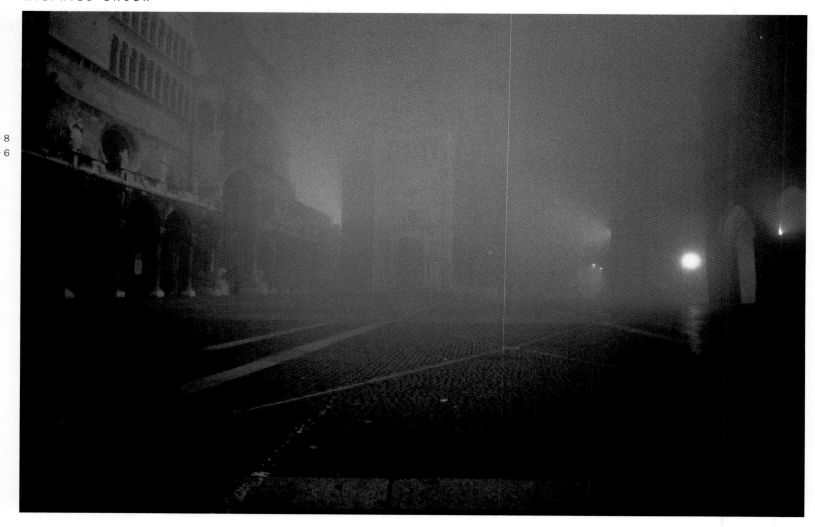

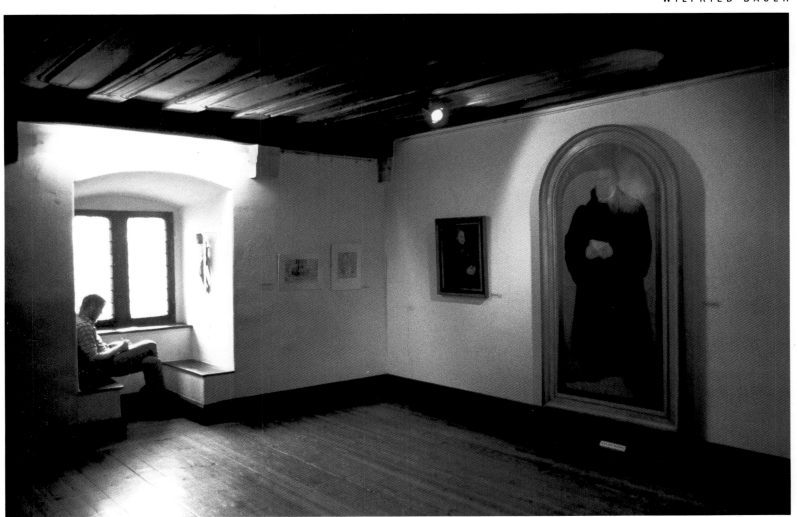

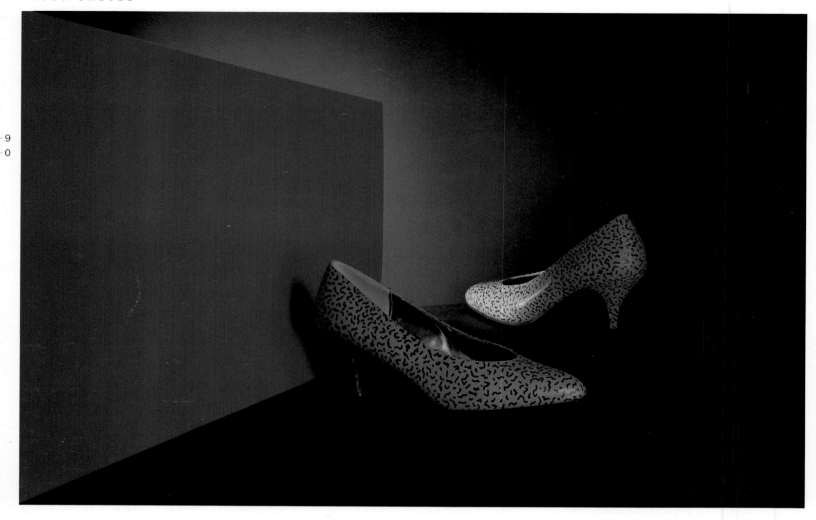

Bernhard Wette Memphis-style shoe.
Art Director · Directeur Artistique · Art Direktor

Chaussure style Memphis.

Paolo Greuel
Designer · Maquettiste · Gestalter Schuh im Memphis-Stil.

Zoom, Germany
Publisher · Editeur · Verleger

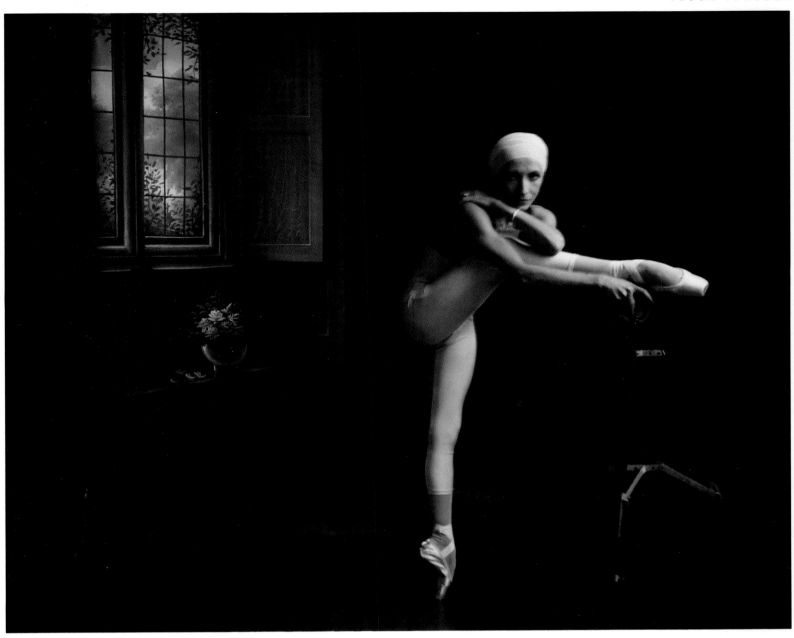

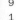

Portrait of Natalya Makarova.

Portrait de Natalya Makarova.

Porträt von Natalya Makarova.

Susan Mann
Art Director · Directeur Artistique · Art Direktor

Susan Mann
Designer · Maquettiste · Gestalter

Clement Crisp
Writer · Auteur · Autor

Vogue, December 1983
Publisher · Editeur · Verleger

April Silver
Art Director · Directeur Artistique · Art Direktor

John Miller
Designer · Maquettiste · Gestalter

Carol Caldwell
Writer · Auteur · Autor

Jennifer Crandall
Picture Editor · Directeur de Photographie · Bildredakteur

Esquire Magazine
Publisher · Editeur · Verleger

Terri Garr and Michael Keaton.

Terri Garr et Michael Keaton.

Terri Garr und Michael Keaton.

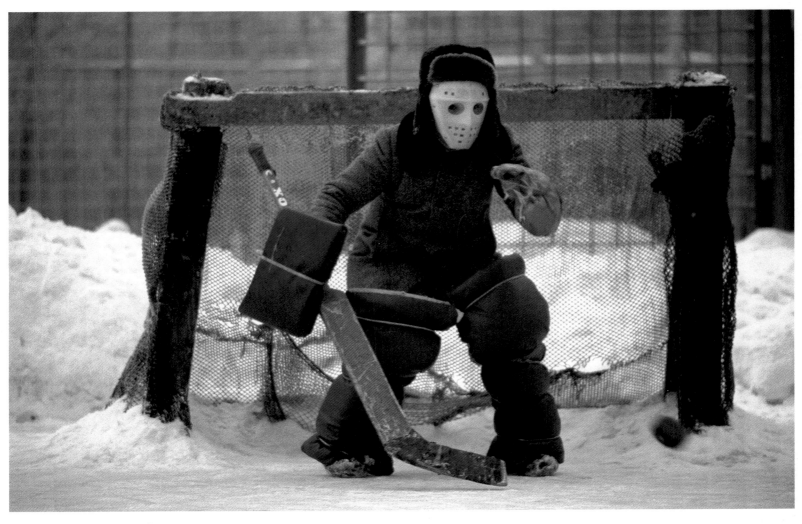

Ice age. Rolf Gillhausen
 Art Director · Directeur Artistique · Art Direktor

Epoque glacière.

Eiszeit. Detlef Schlottmann
 Designer · Maquettiste · Gestalter

 Stern, No. 30
 Publisher · Editeur · Verleger

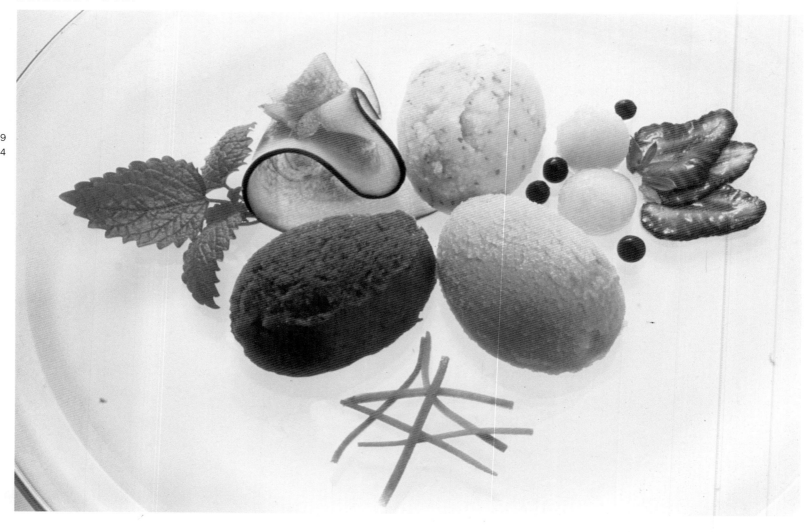

Rolf Gillhausen
Art Director · Directeur Artistique · Art Direktor

Detlef Schlottmann
Designer · Maquettiste · Gestalter

Stern, No. 38
Publisher · Editeur · Verleger

Cold delight.

Délice froid.

Die Kalte Pracht.

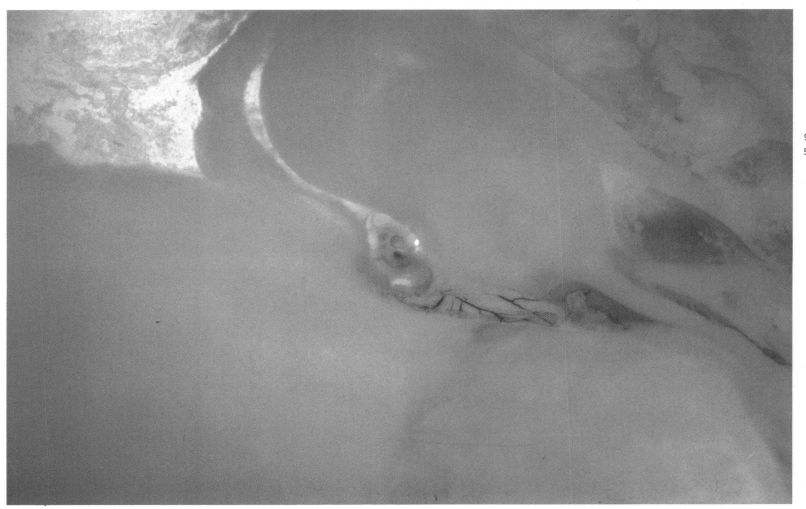

Reportage to illustrate an article on fertilization. Pages 95 to 97

Reportage pour illustrer un article sur la fécondation. Illustré Magazine, Switzerland
Publisher · Editeur · Verleger

Reportage zur Illustration eines Artikels über die
Befruchtung.

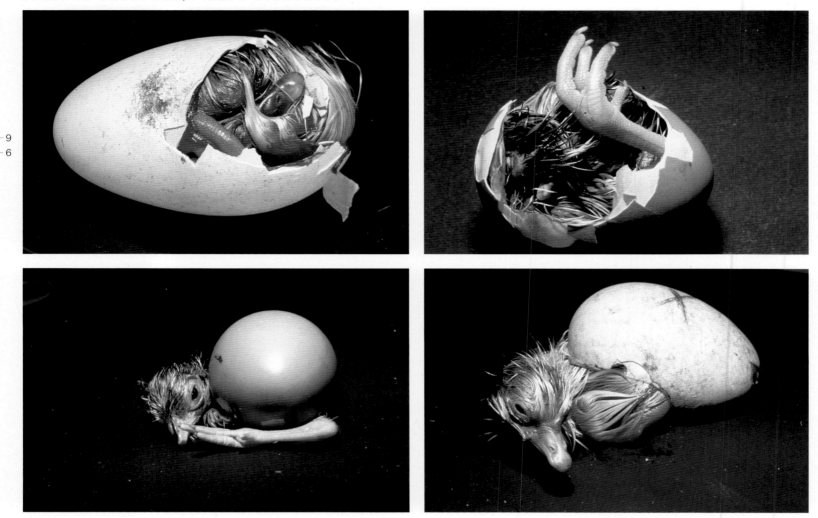

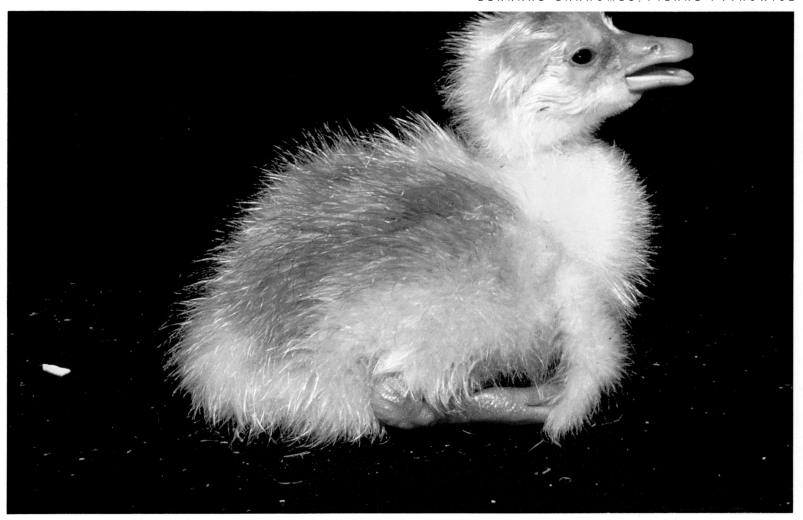

Pages 98, 99 A Midsummer Night's Dream (Courtesy of Vogue, Paris).

Songe d'une nuit d'été (Avec l'aimable concours de Vogue, Paris).

Ein Sommernachtstraum (mit freundlicher Genehmigung von Vogue, Paris).

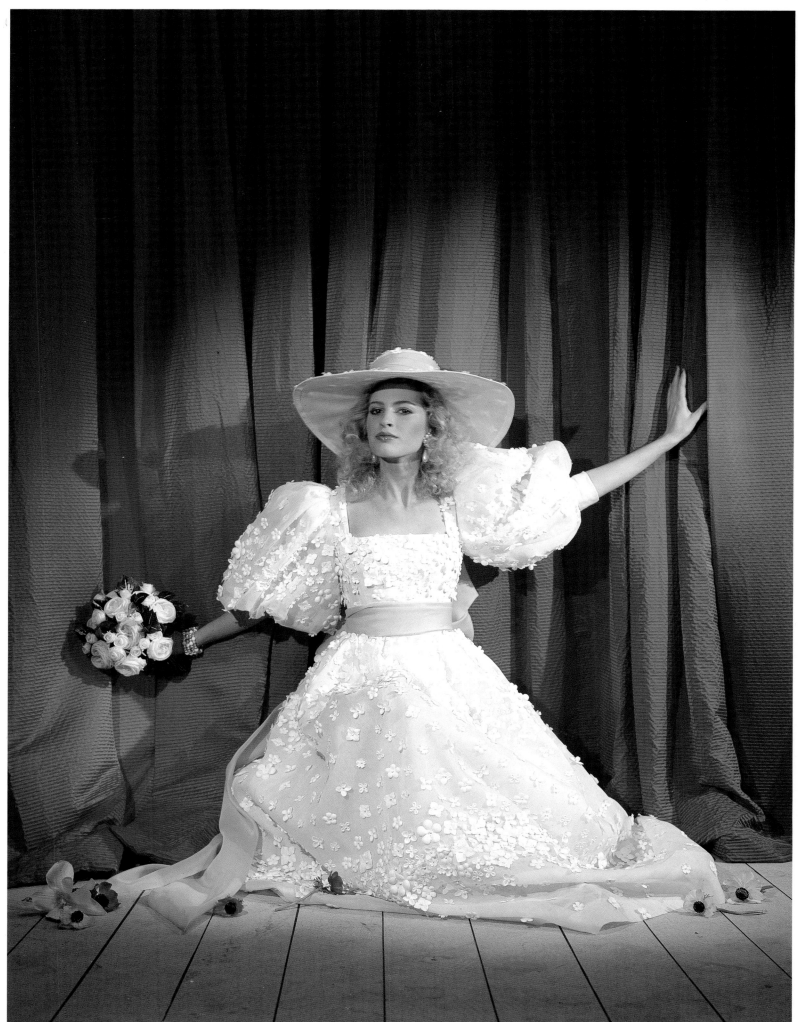

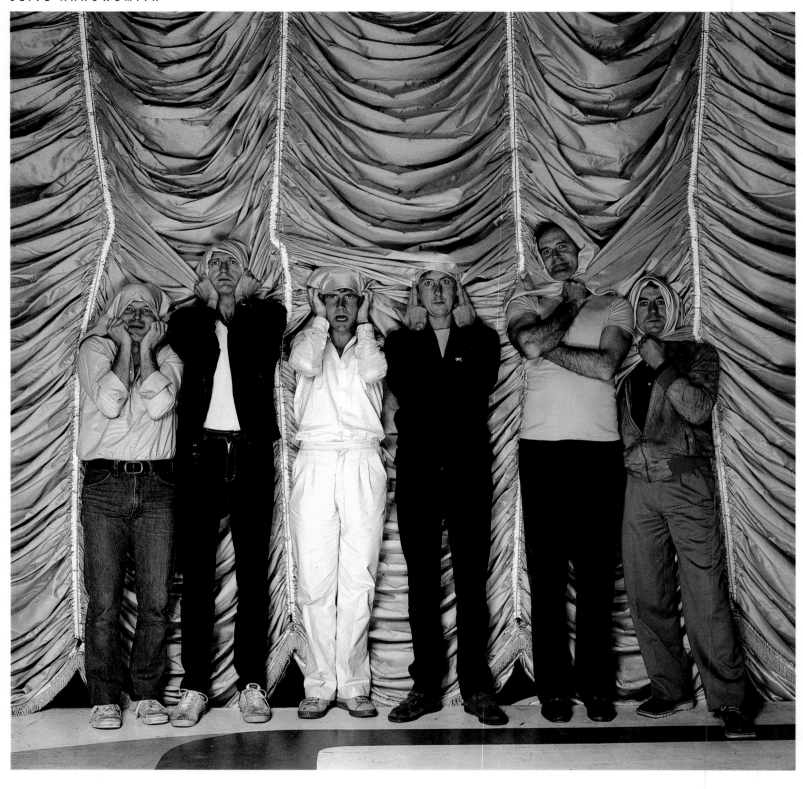

George Perry Monty Python Team.
Writer · Auteur · Autor

 L'équipe Monty Python.

James Danziger
Picture Editor · Directeur de Photographie · Bildredakteur Das Monty Python Team.

Sunday Times Magazine, June 1983
Publisher · Editeur · Verleger

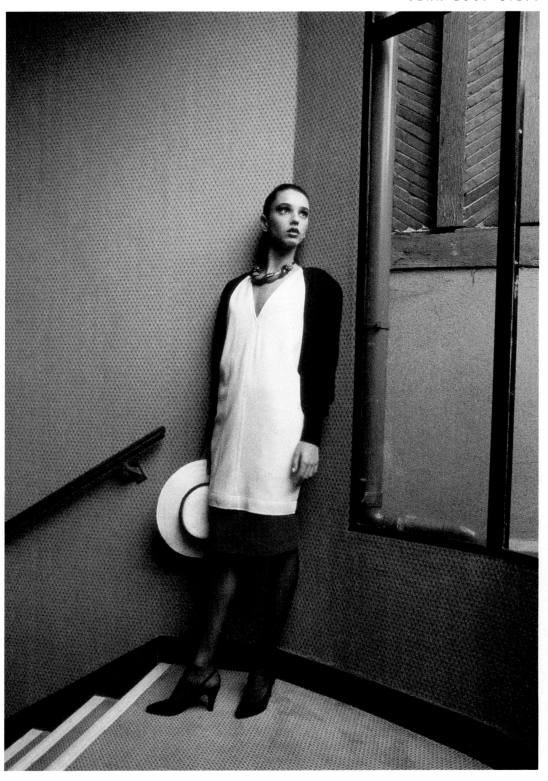

Fashion for Vogue. Vogue, Paris, February 1984
Publisher · Editeur · Verleger
La mode pour Vogue.

Mode für Vogue.

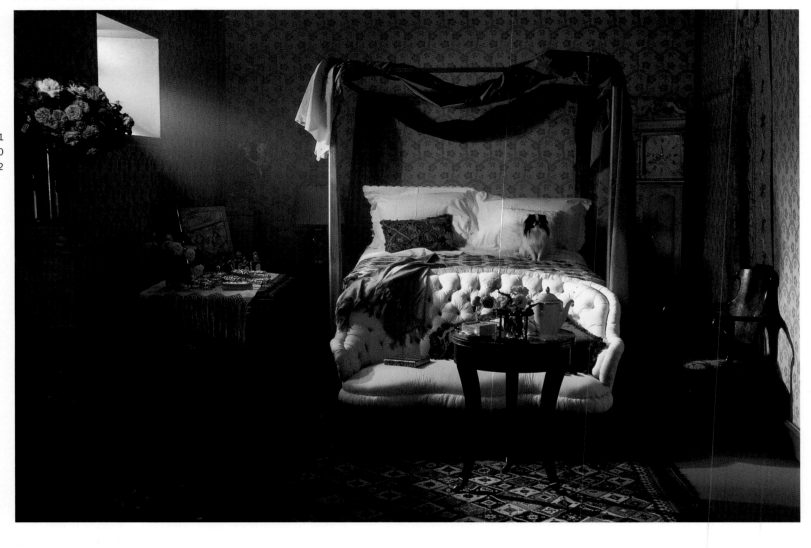

Judy Brittain
Art Director · Directeur Artistique · Art Direktor

The Most of Christmas Morning.

Le meilleur du jour de Noël.

Vogue, December 1982
Publisher · Editeur · Verleger

Das Beste des Weihnachtsmorgens.

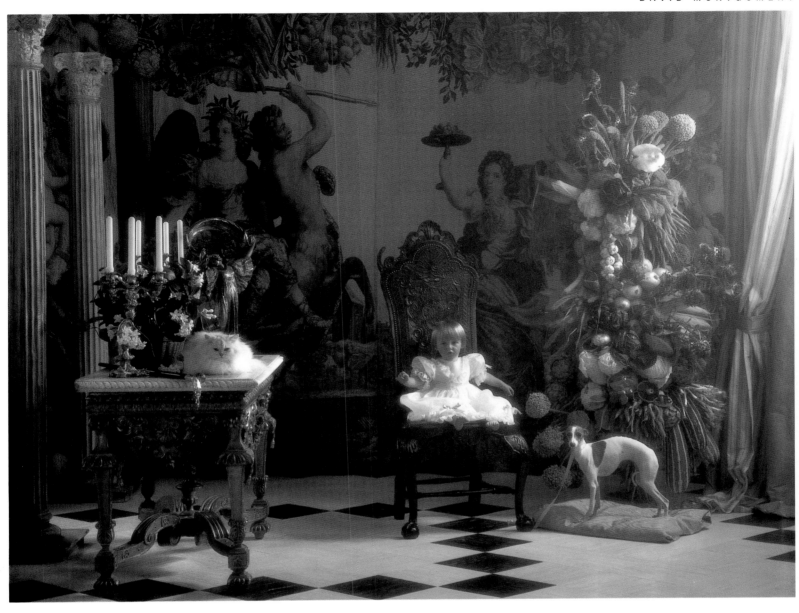

Photograph for a feature entitled: Surprise Giving.

Photographie pour un article intitulé: Surprise Giving
(Cadeaux surprises).

Foto für eine Reportage mit dem Titel: Surprise Giving
(Überraschende Geschenke).

Susan Mann
Art Director · Directeur Artistique · Art Direktor

Judy Brittain
Designer · Maquettiste · Gestalter

Judy Brittain
Writer · Auteur · Autor

Vogue, December 1983
Publisher · Editeur · Verleger

Photograph for a feature entitled: Art Class

Photographie pour un article intitulé: Art Class (Cours de
dessein).

Foto für eine Reportage mit dem Titel: Art Class
(Zeichenstunde)

Pages 104, 105

Susan Mann
Art Director · Directeur Artistique · Art Direktor

Judy Brittain
Designer · Maquettiste · Gestalter

Judy Brittain
Writer · Auteur · Autor

Vogue, September 1981
Publisher · Editeur · Verleger

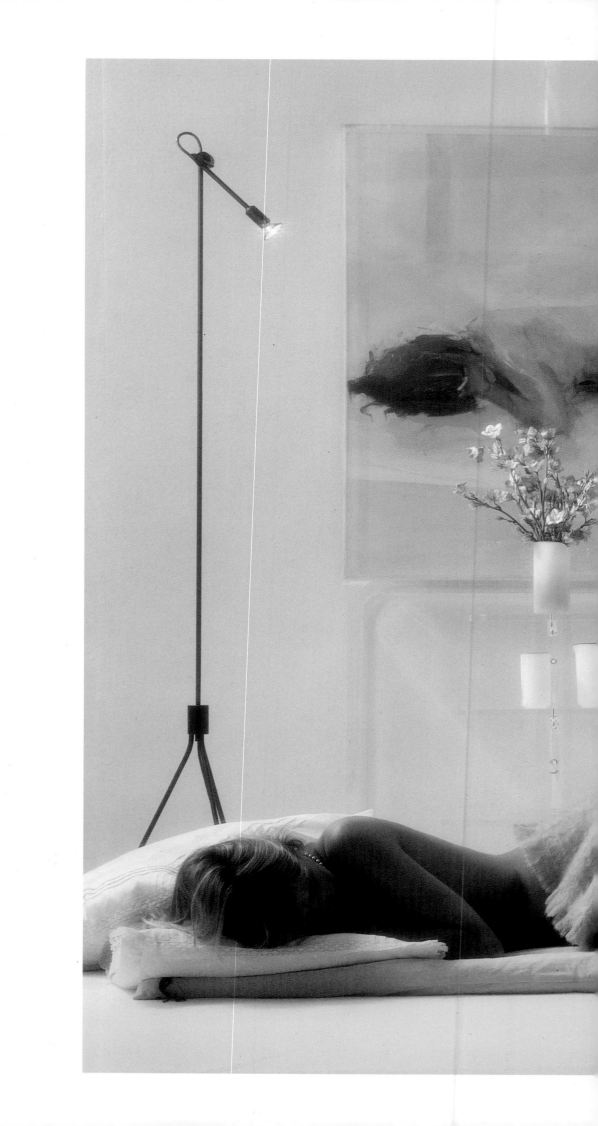

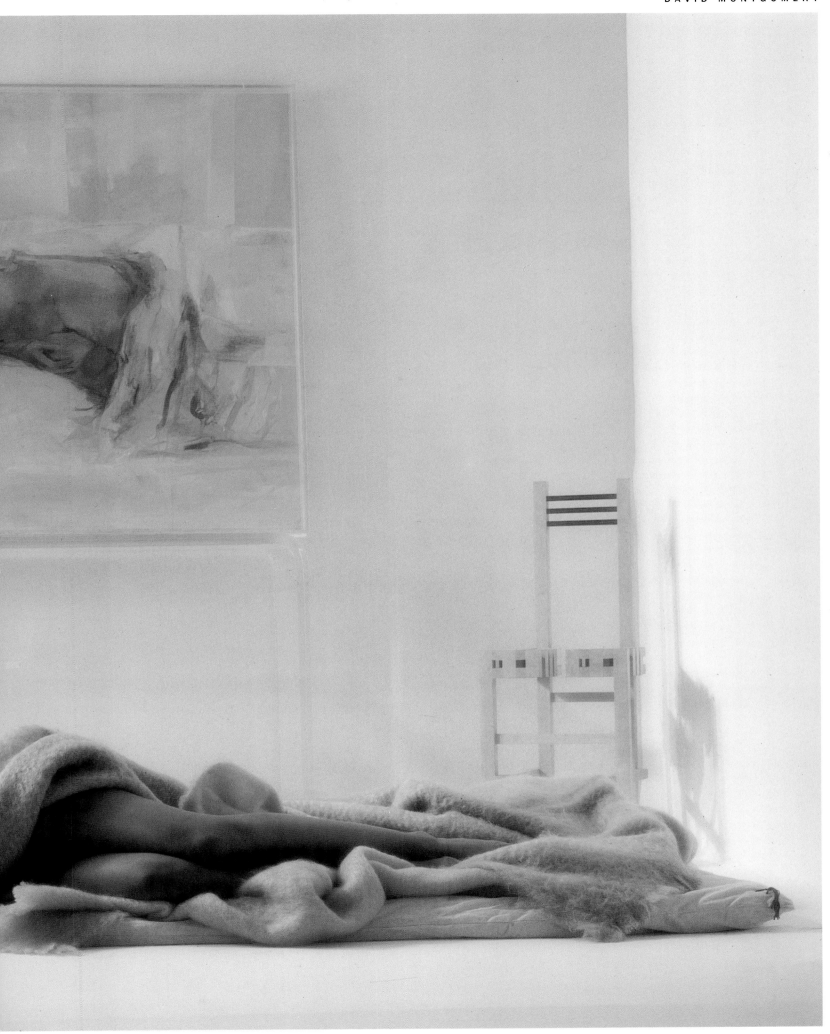

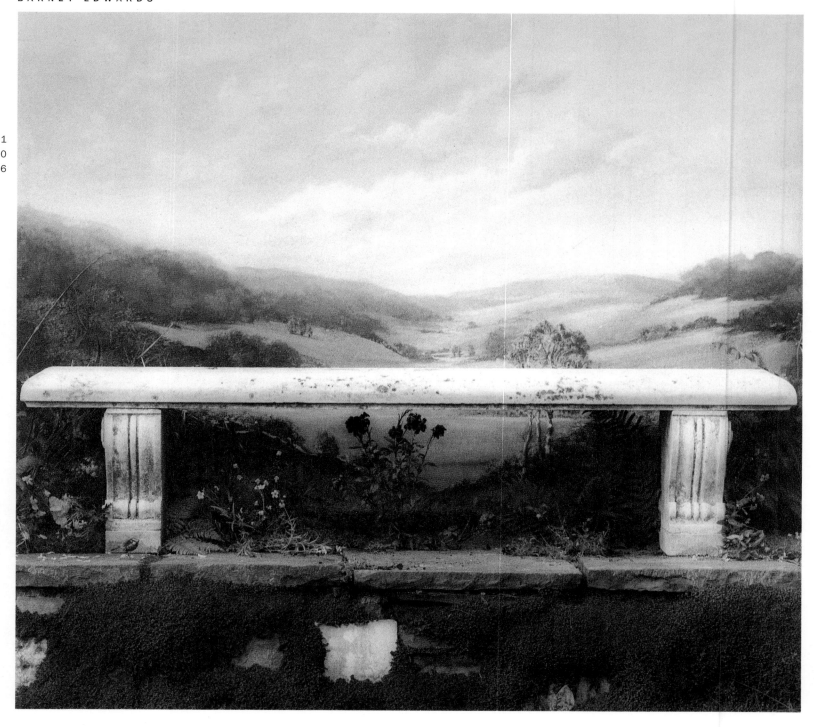

Wendy Harrop
Art Director · Directeur Artistique · Art Direktor

Wendy Harrop
Designer · Maquettiste · Gestalter

Mario Amaya
Writer · Auteur · Autor

The World of Interiors, Sept 1983
Publisher · Editeur · Verleger

The Sward and the Stone.

Le gazon et la pierre.

Der Rasen und der Stein.

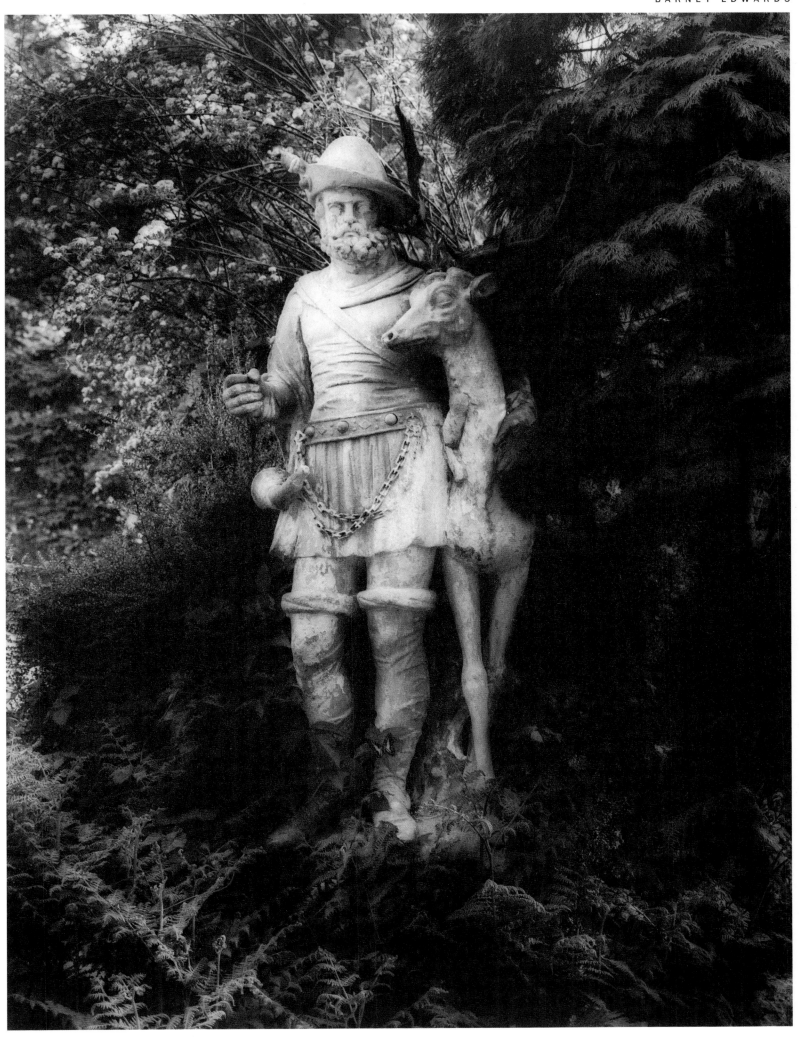

JOE PARTRIDGE

James Danziger Easy Monet.
Picture Editor · Directeur de Photographie · Bildredakteur

 Rendre Monet.
Sunday Times Magazine, February 19, 1984
Publisher · Editeur · Verleger Monet leicht.

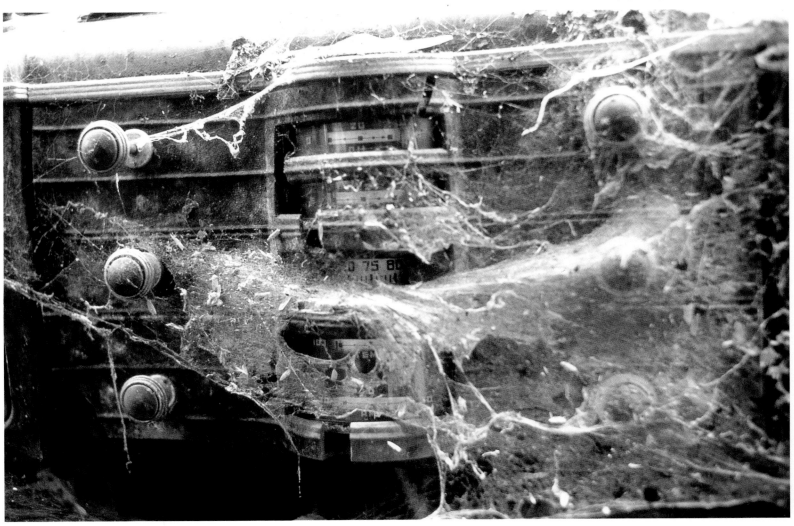

Millions in scrap metal. Pages 109 to 114

Des millions en ferraille. Wolfgang Behnken
Art Director · Directeur Artistique · Art Direktor

Der Millionen Schrott.

Dietmar Schultze
Designer · Maquettiste · Gestalter

Stern, No. 36
Publisher · Editeur · Verleger

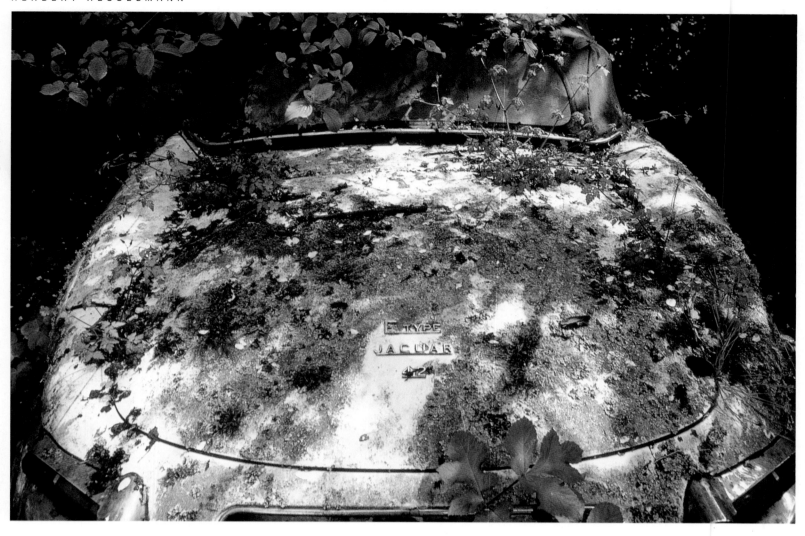

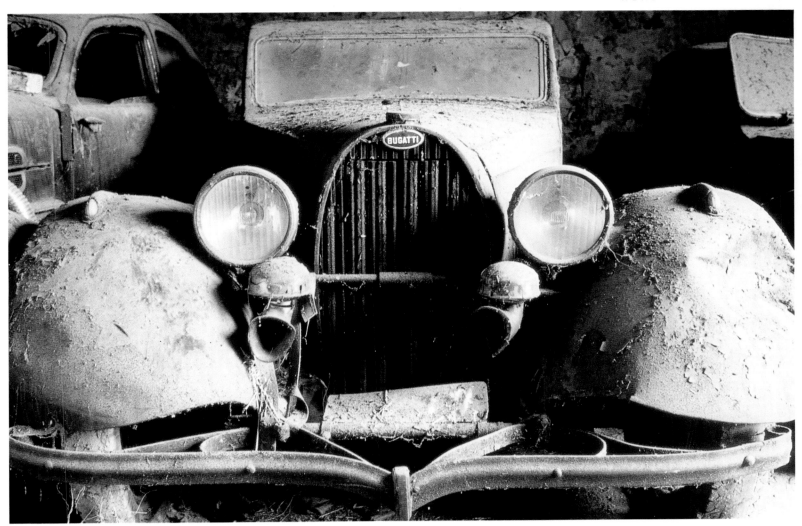

1
1
1

1
1
2

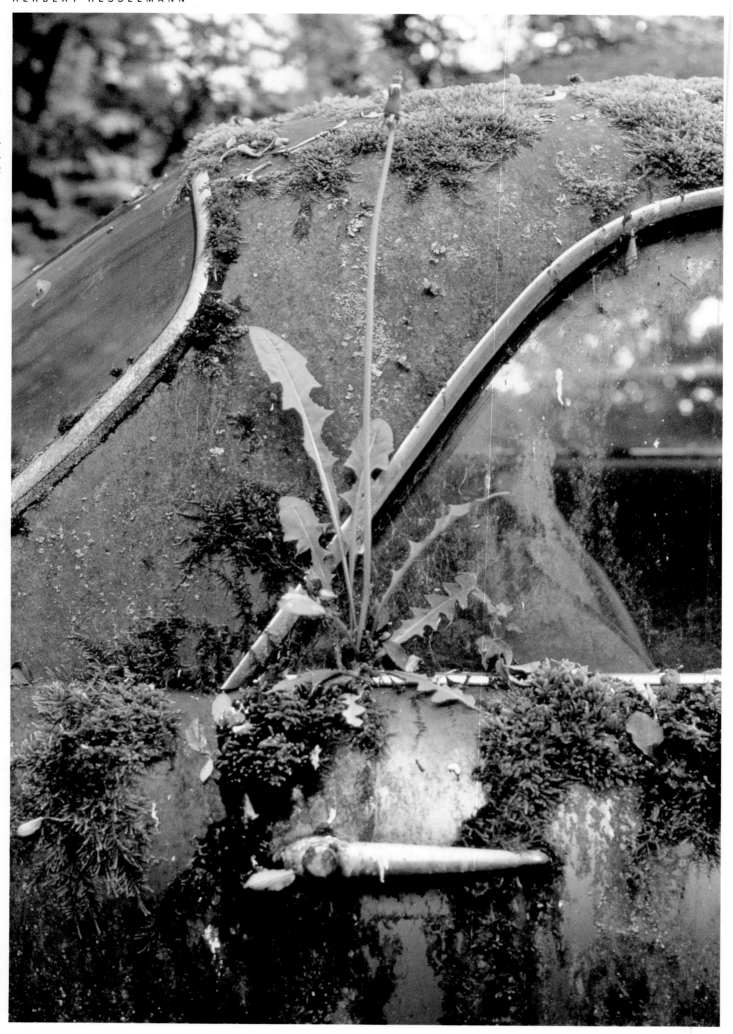

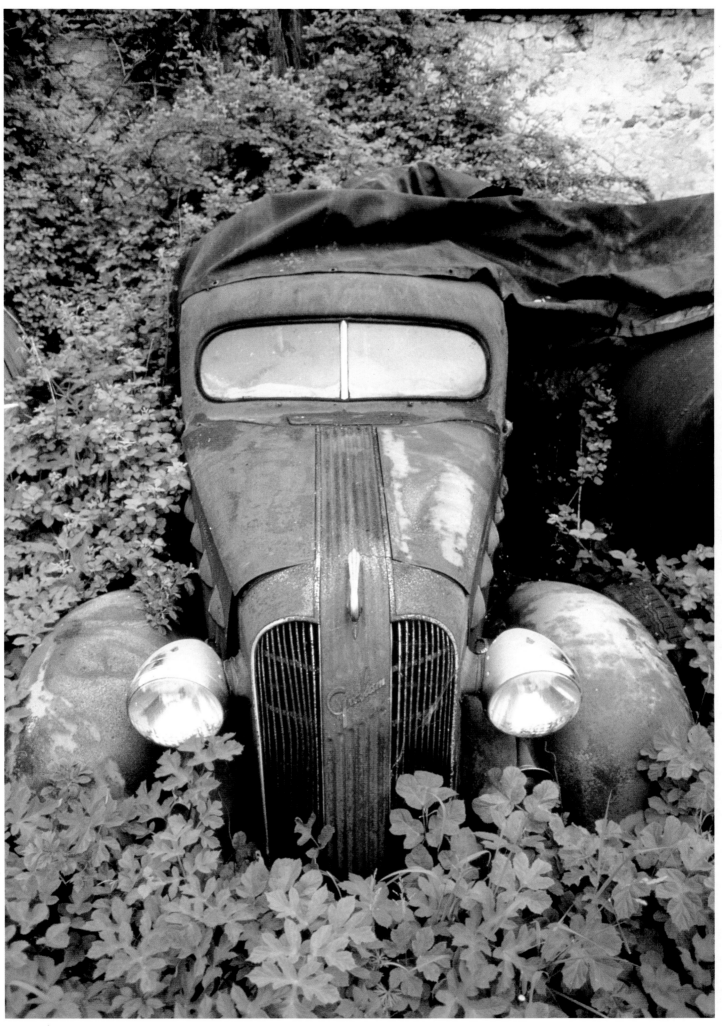

1
1
3

1
1
4

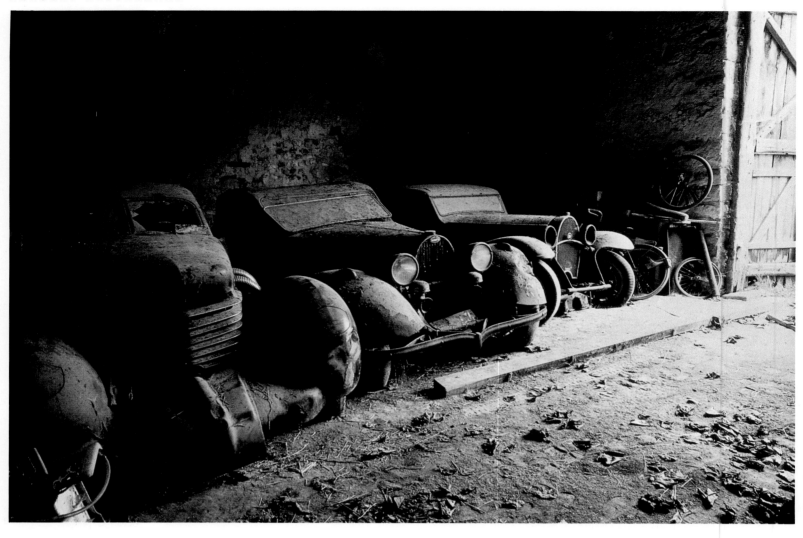

Marble. Rolf Gillhausen
 Art Director · Directeur Artistique · Art Direktor
Marbre.
 Walter Strenge
Marmor. Designer · Maquettiste · Gestalter

 Stern, No. 40
 Publisher · Editeur · Verleger

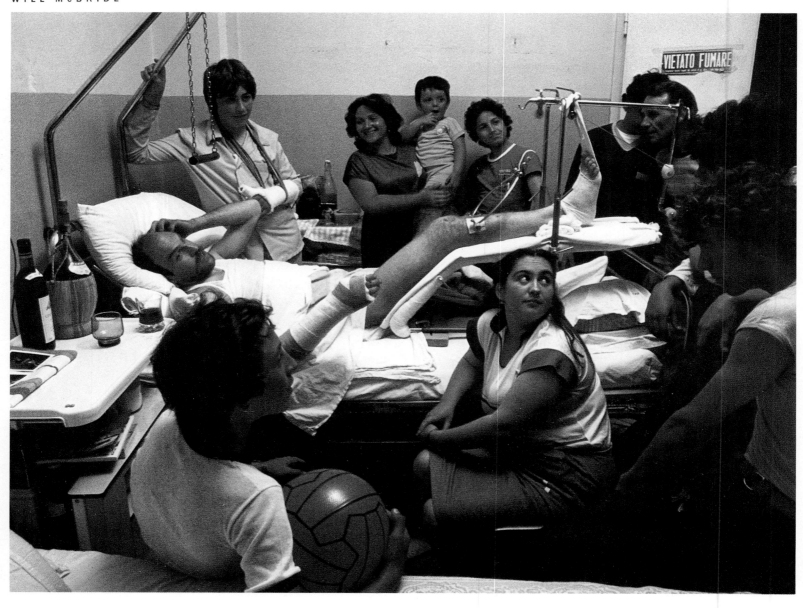

Rolf Gillhausen My Italy.
Art Director · Directeur Artistique · Art Direktor

Mon Italie.

Franz Epping
Designer · Maquettiste · Gestalter Mein Italien.

Stern, No. 29
Publisher · Editeur · Verleger

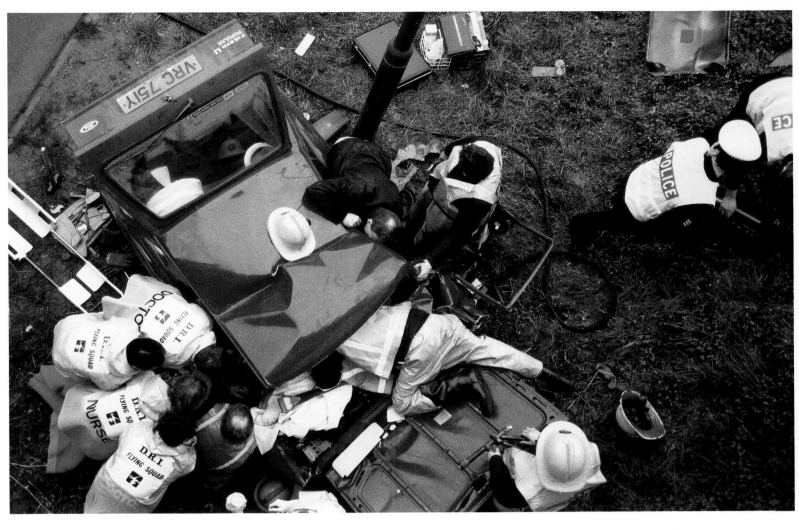

Car Crash on New Stores Road By-pass, Derby, for feature
entitled: The Life Savers.

Jane Gould
Art Director · Directeur Artistique · Art Direktor

Accident de la route près de Derby pour un article intitulé:
The Life Savers (Les sauveteurs).

Peter Martin
Writer · Auteur · Autor

Autounfall auf der New Stores Umgehungsstraße, Derby,
für eine Reportage mit dem Titel: The Life Savers (Die
Lebensretter).

Mail on Sunday, You Magazine
Publisher · Editeur · Verleger

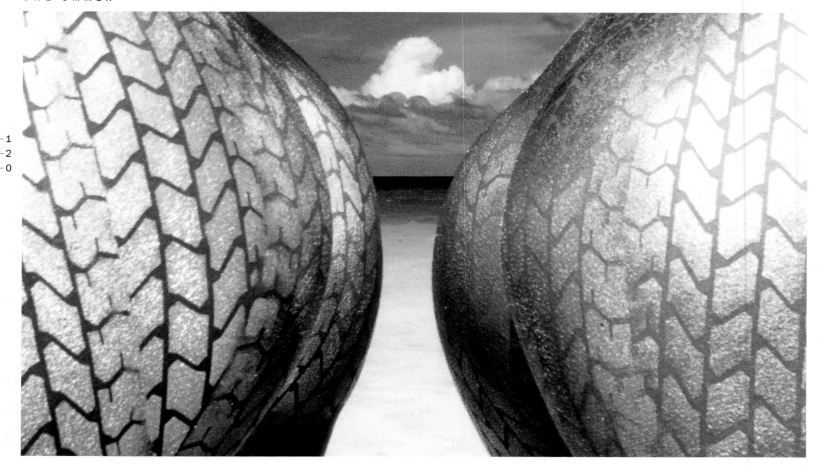

Pages 120, 121 Tyre Tread.

Martyn Walsh Chape de pneu.
Art Director · Directeur Artistique · Art Direktor

Reifenprofil.

Martyn Walsh
Designer · Maquettiste · Gestalter

Pirelli Calendar
Publisher · Editeur · Verleger

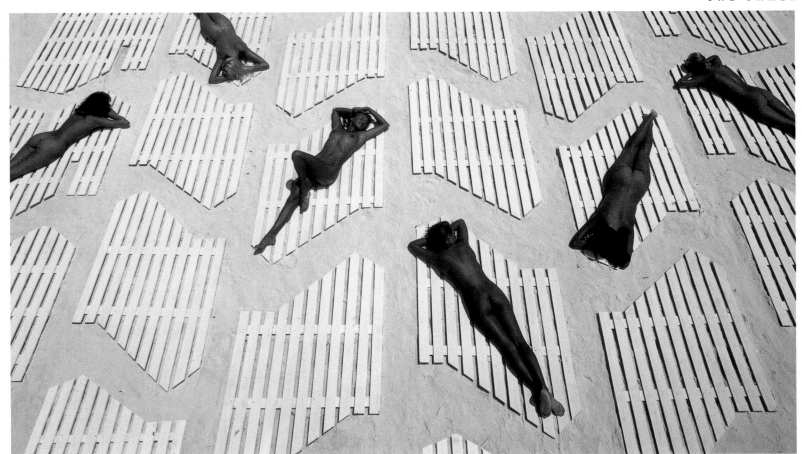

1
2
1

1
2
2

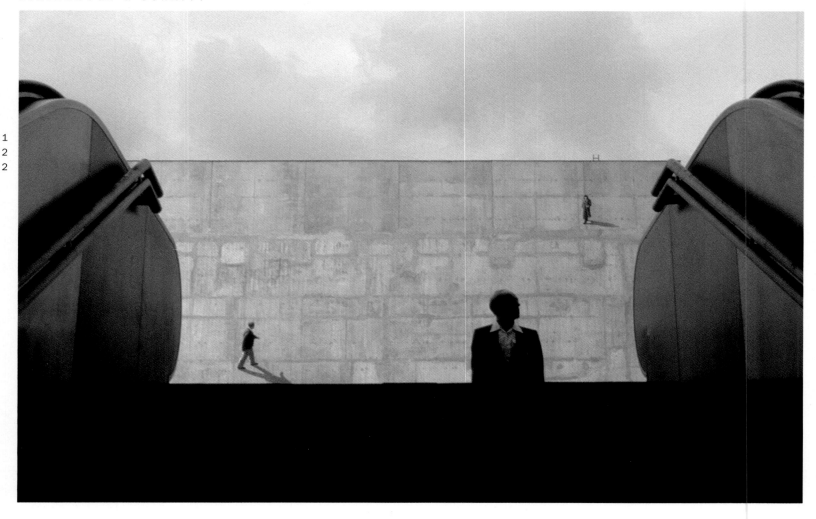

Hartmut Brückner Paris, Forum des Halles.
Designer · Maquettiste · Gestalter

Bilderberg Calendar
Publisher · Editeur · Verleger

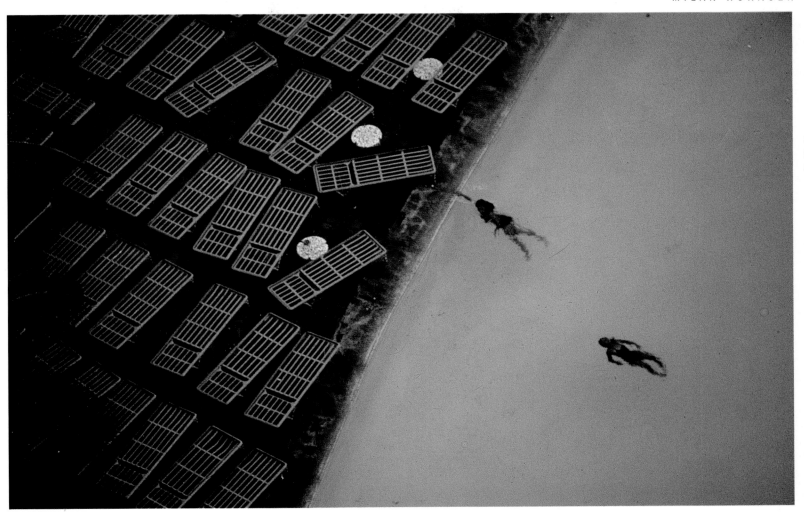

1 ——
2 ——
3 ——

Hotel Interconti, Acapulco. Hartmut Brückner
Designer · Maquettiste · Gestalter

Bilderberg Calendar
Publisher · Editeur · Verleger

Cabin on the cruise liner 'Norway.' Pages 124, 125

Cabine sur le paquebot 'Norway.' Hartmut Brückner
Designer · Maquettiste · Gestalter

Kabine auf dem Dampfer 'Norway.'

Bilderberg Calendar
Publisher · Editeur · Verleger

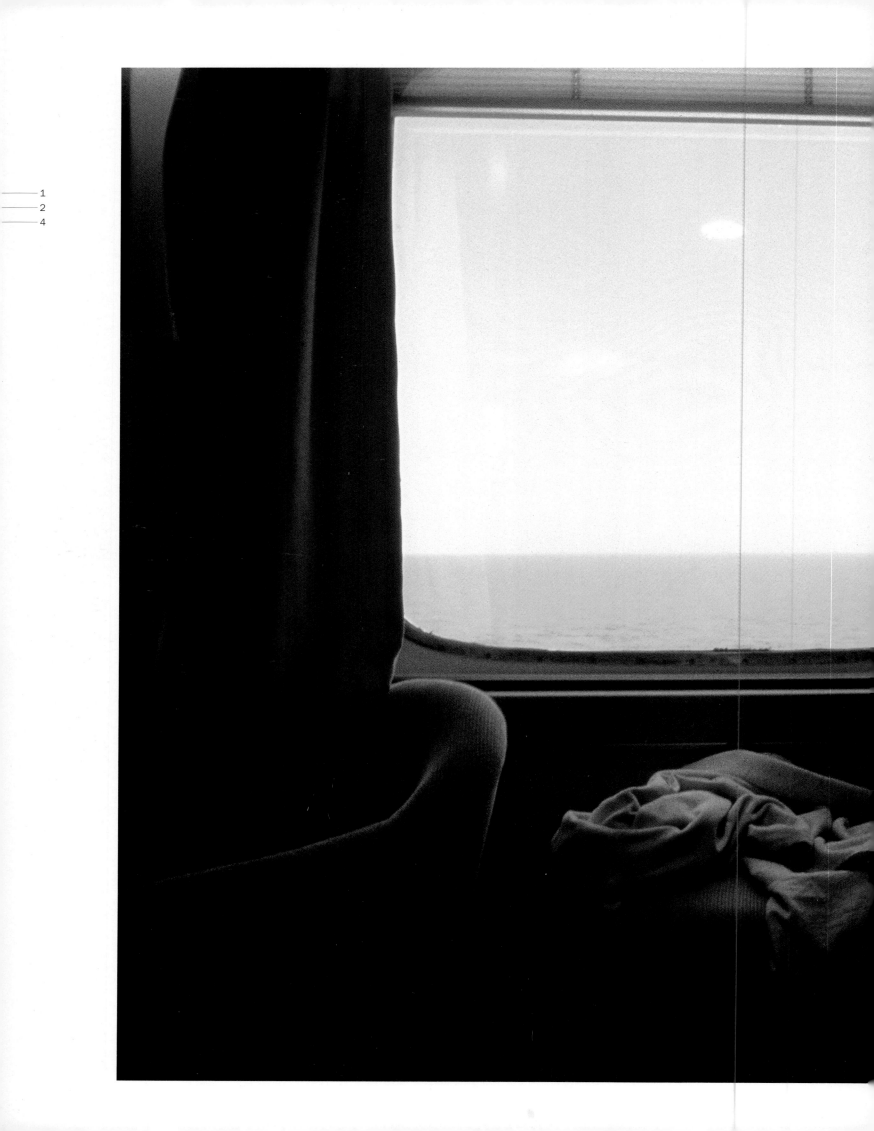

1
2
4

KLAUS BOSSEMEYER

1
2
5

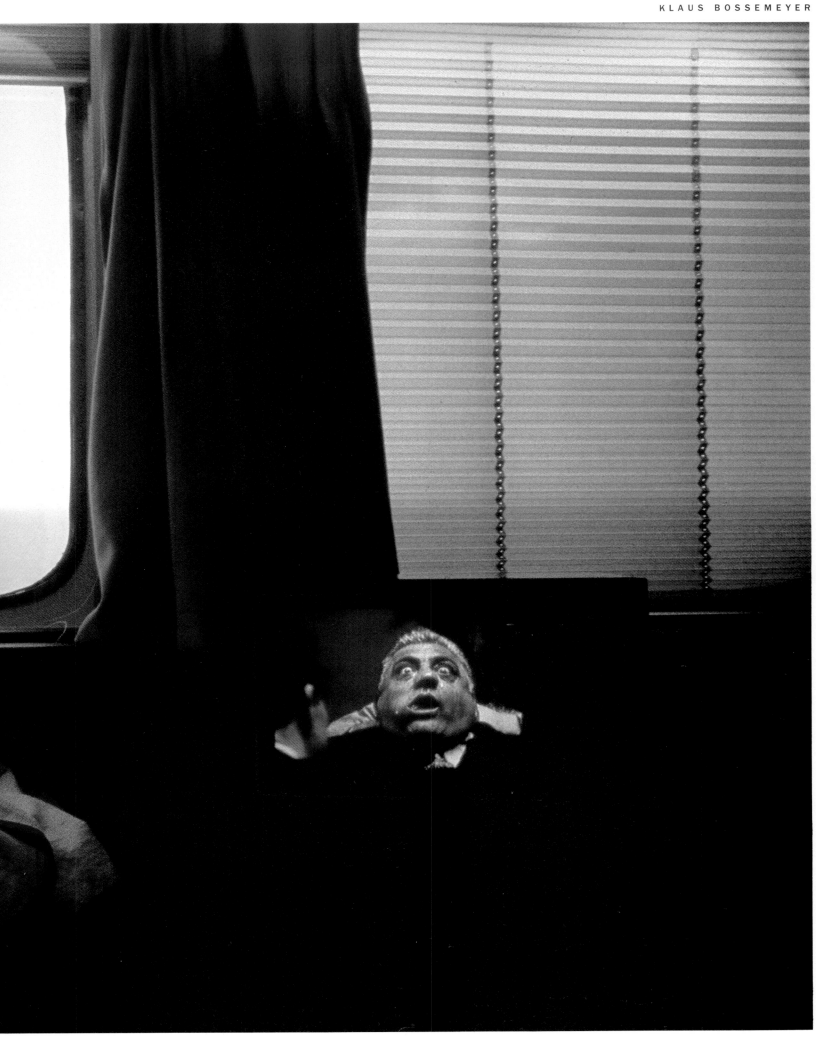

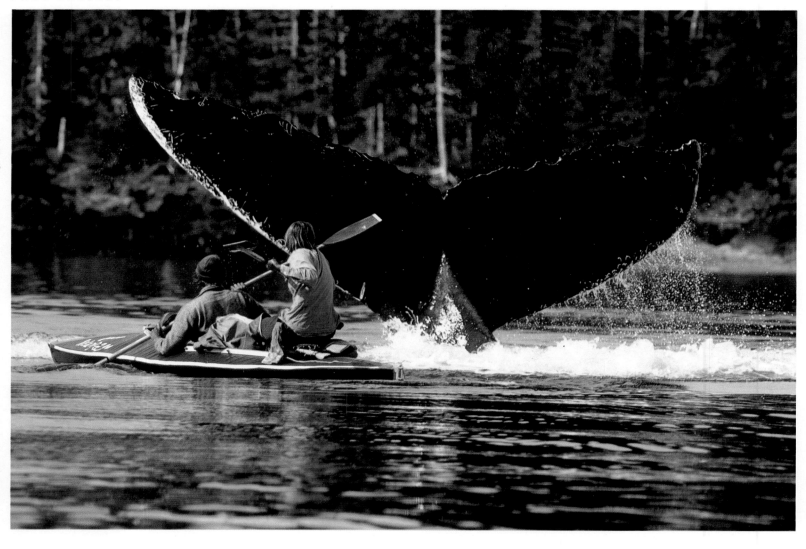

1
2
6

Franz Epping
Art Director · Directeur Artistique · Art Direktor

Gerhard Äckerle
Picture Editor · Directeur de Photographie · Bildredakteur

Stern Year Book, 1983
Publisher · Editeur · Verleger

Suddenly he held out his fins.

Soudain, il deploya ses nageoirs.

Plötzlich hält er seine Flosse hin.

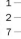

1 ——
2 ——
7 ——

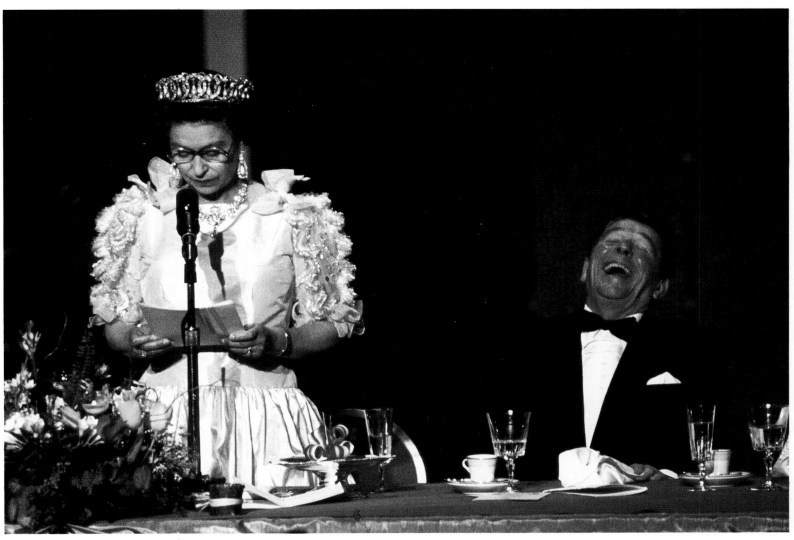

The triumph of British humour. Franz Epping
 Art Director · Directeur Artistique · Art Direktor

La triomphe de l'humour Britannique.

 Gerhard Äckerle
Der Sieg des britischen Humors. Picture Editor · Directeur de Photographie · Bildredakteur

 Stern Year Book, 1983
 Publisher · Editeur · Verleger

1
2
8

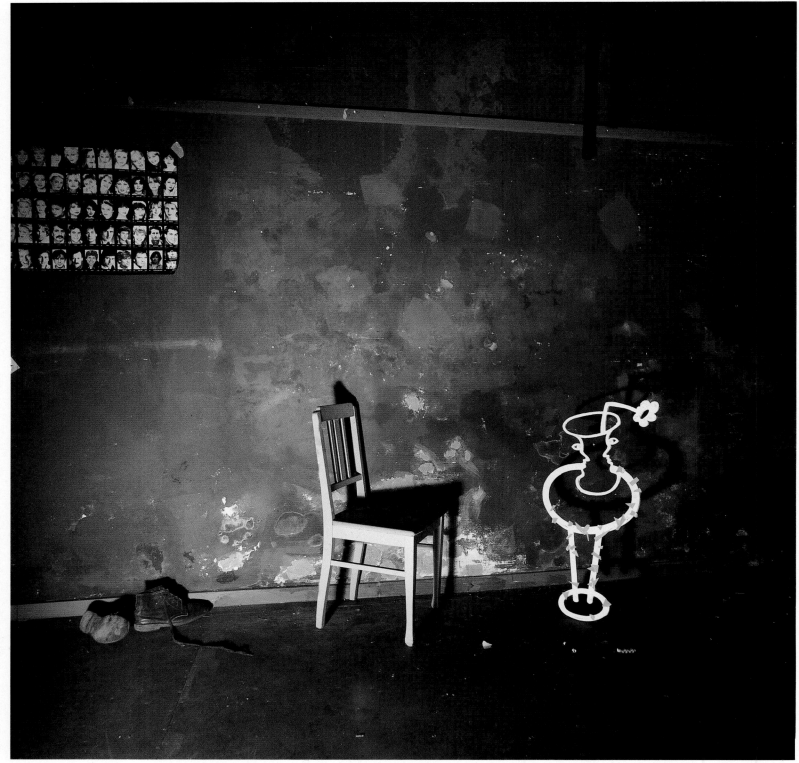

Gert Dumbar
Art Director · Directeur Artistique · Art Direktor

Book cover for Gids voor Gescheiden Mensen. (Guide for divorced people).

Ivo Pothaar & Hans Tieken
Writer · Auteur · Autor

Couverture du livre: Gids voor Gescheiden Mensen. (Guide pour les divorcés).

Bert Bukker
Publisher · Editeur · Verleger

Buchumschlag für Gids voor Gescheiden Mensen. (Handbuch für geschiedene Leute).

Pages 129 to 133

Cusco, Peru.

Robert Hadrill
Designer · Maquettiste · Gestalter

John Hemmings
Writer · Auteur · Autor

The New Pyramid Press: The New Incas
Publisher · Editeur · Verleger

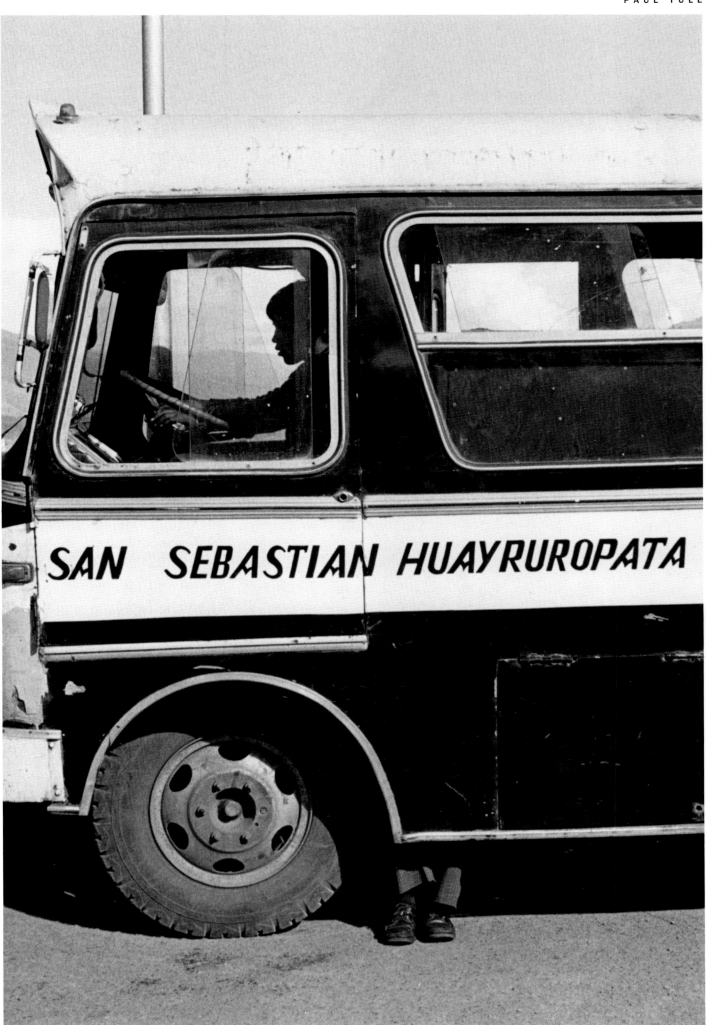

1
2
9

1
3
1

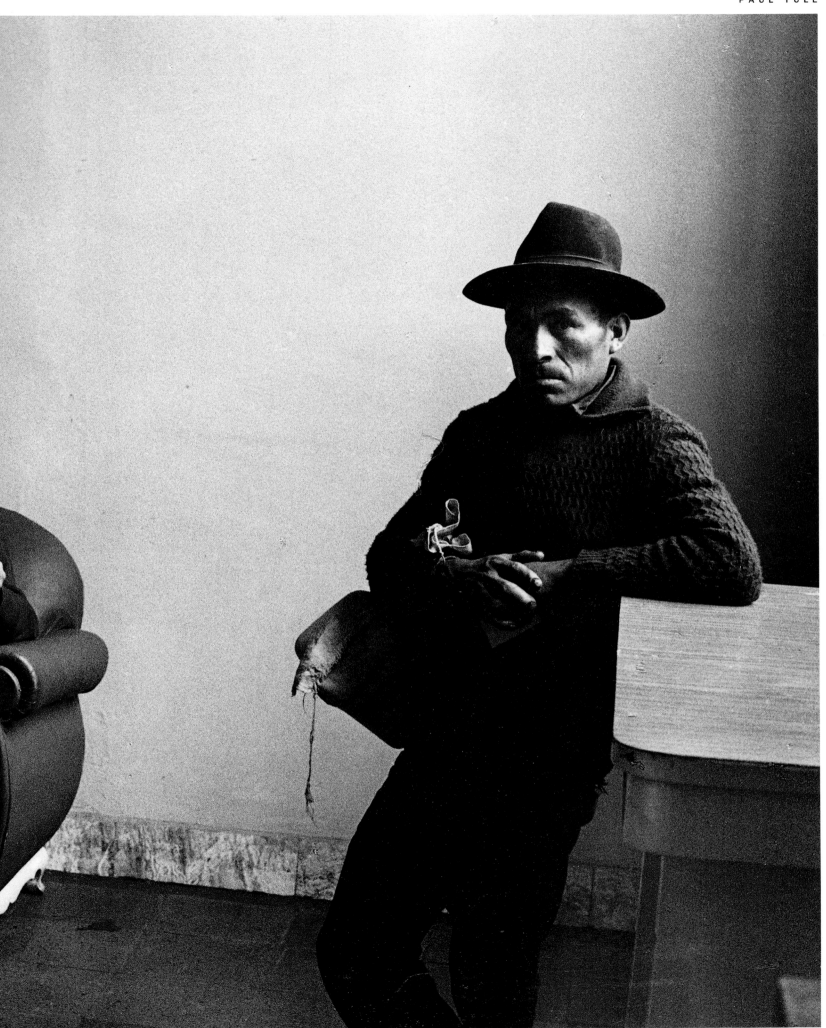

1
3
2

1
3
4

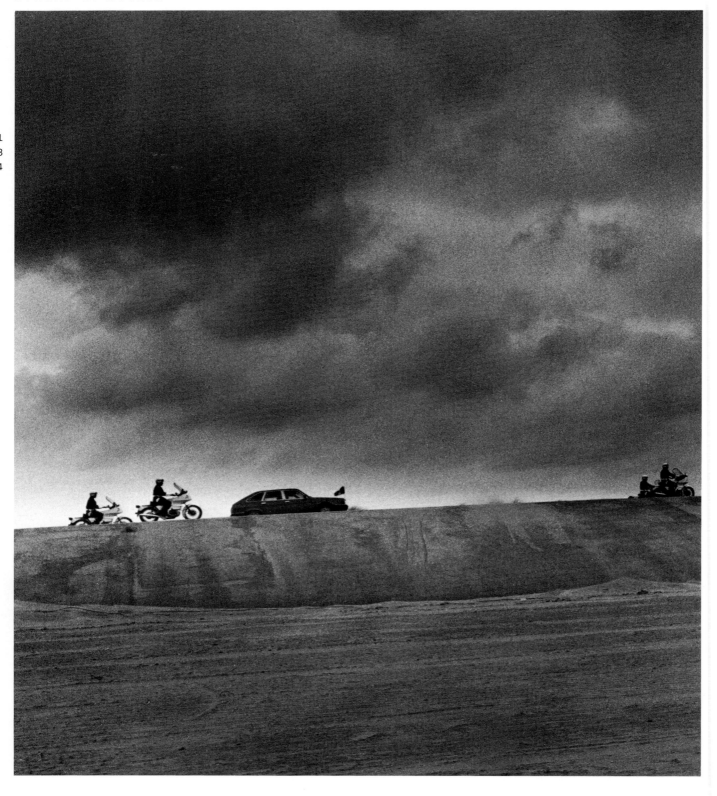

Pages 134 to 143

Henri Flammarion
Art Director · Directeur Artistique · Art Direktor

Konrad Müller
Designer · Maquettiste · Gestalter

Michel Tournier
Writer · Auteur · Autor

Editions Flammarion, Paris
Publisher · Editeur · Verleger

From the Book: 'François Mitterand'.

Du livre: 'François Mitterand'.

Aus dem Buch: 'François Mitterand'.

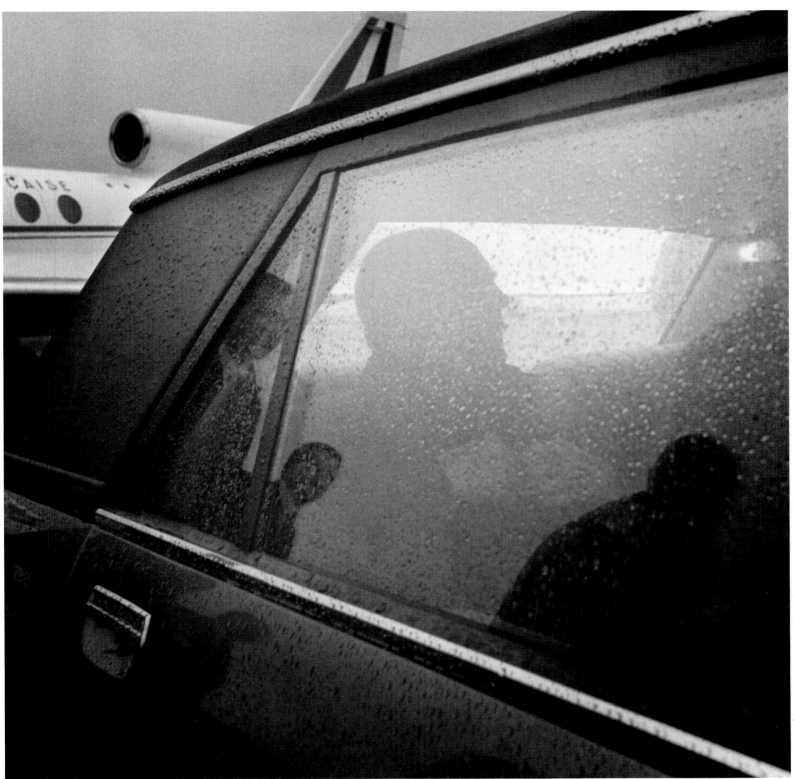

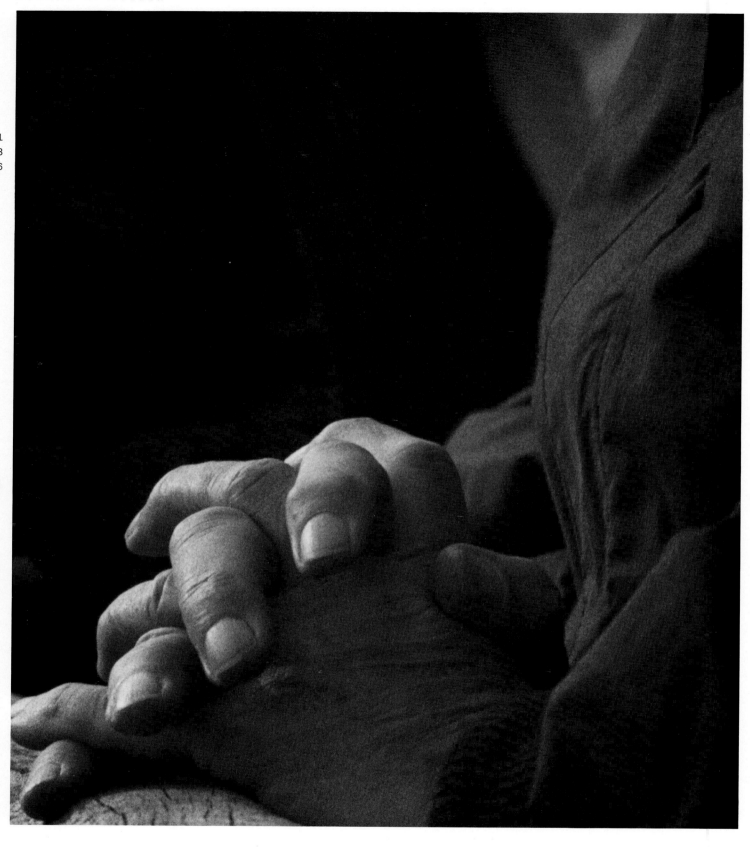

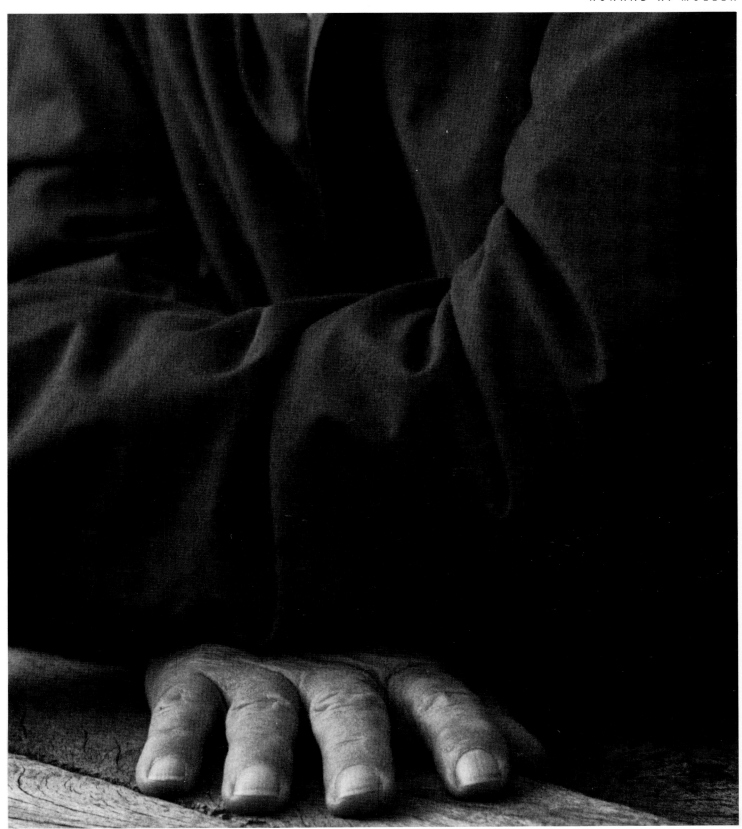

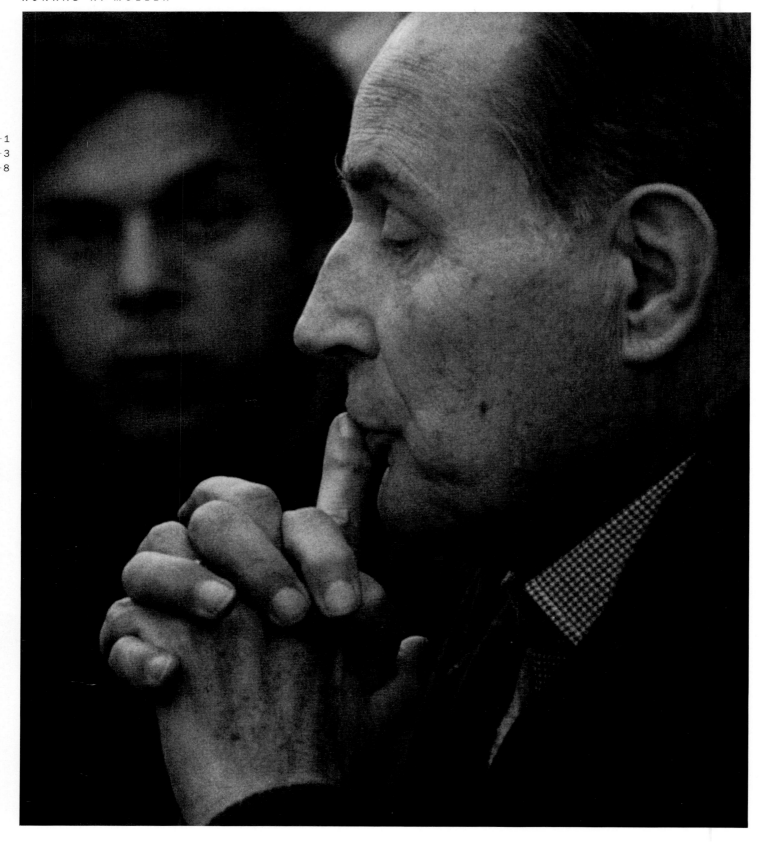

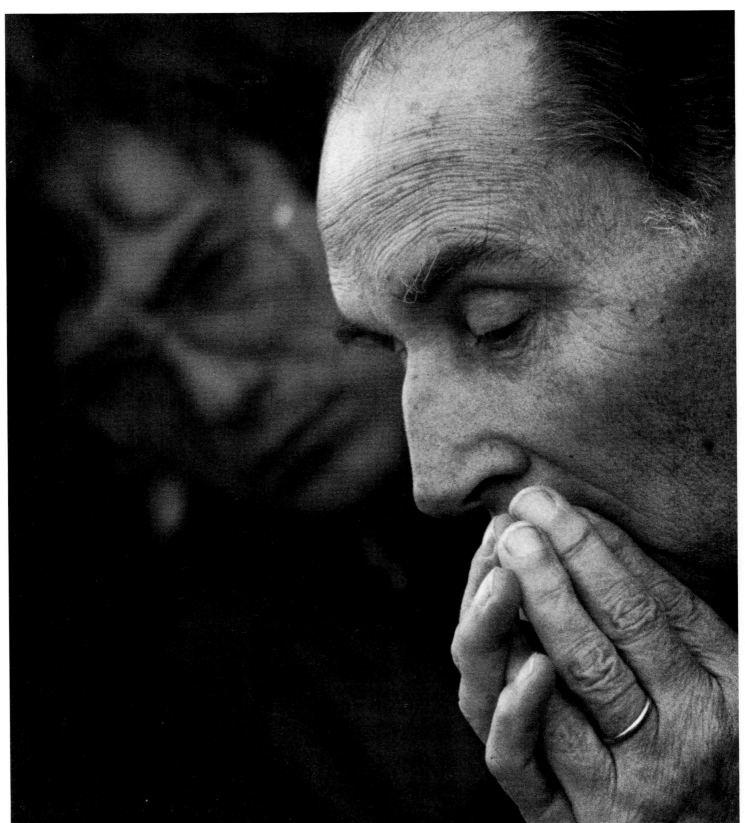

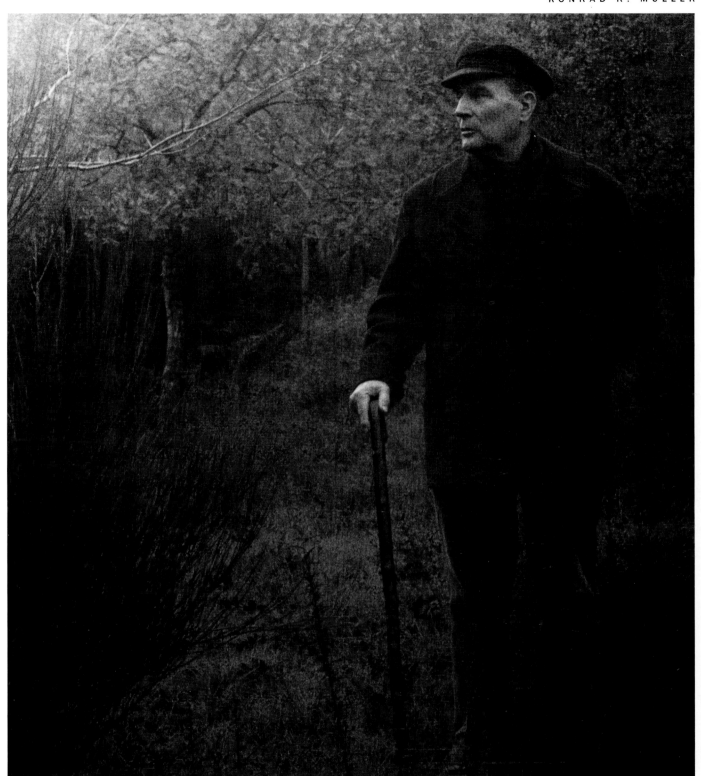

1
4
2

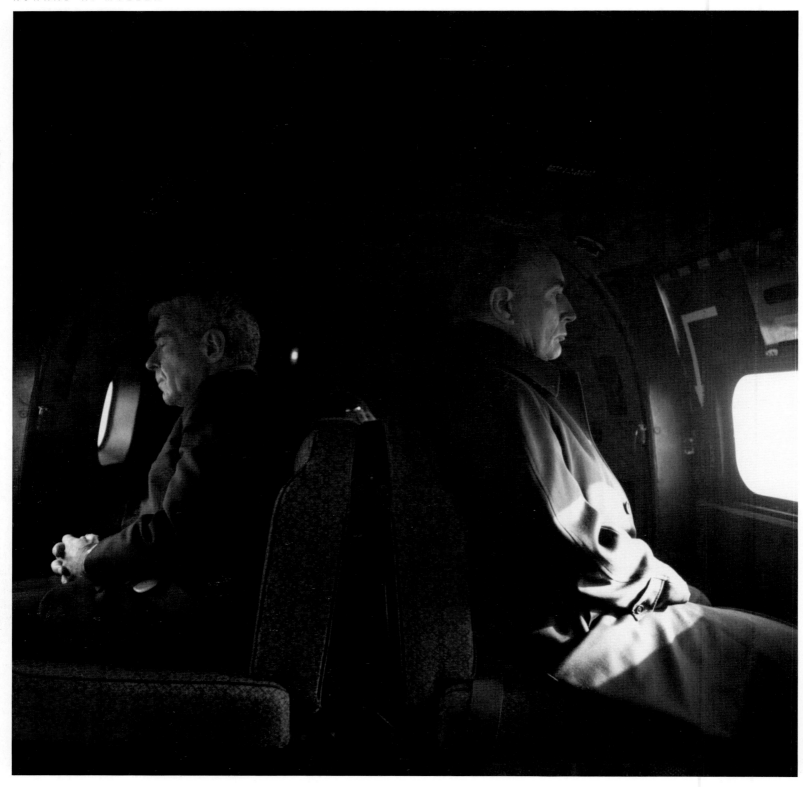

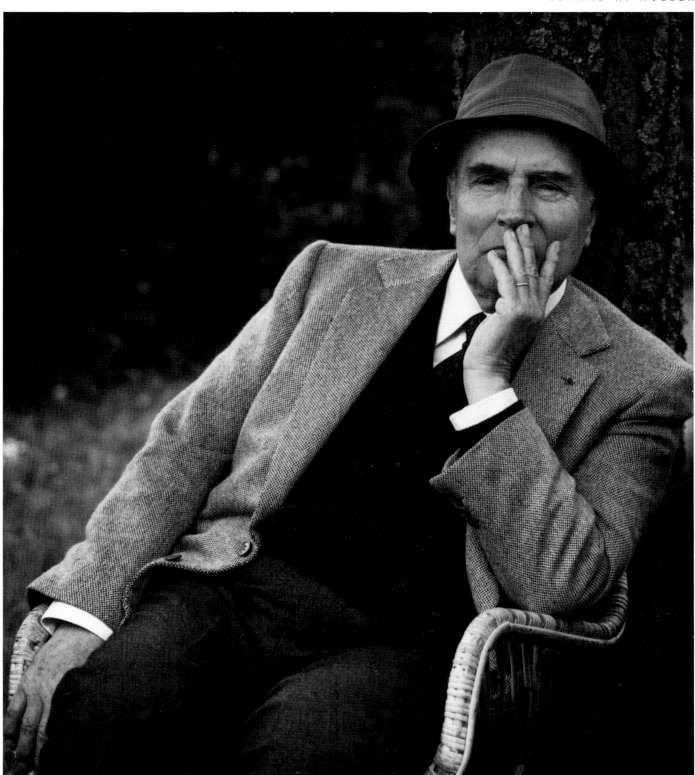

1
4
4

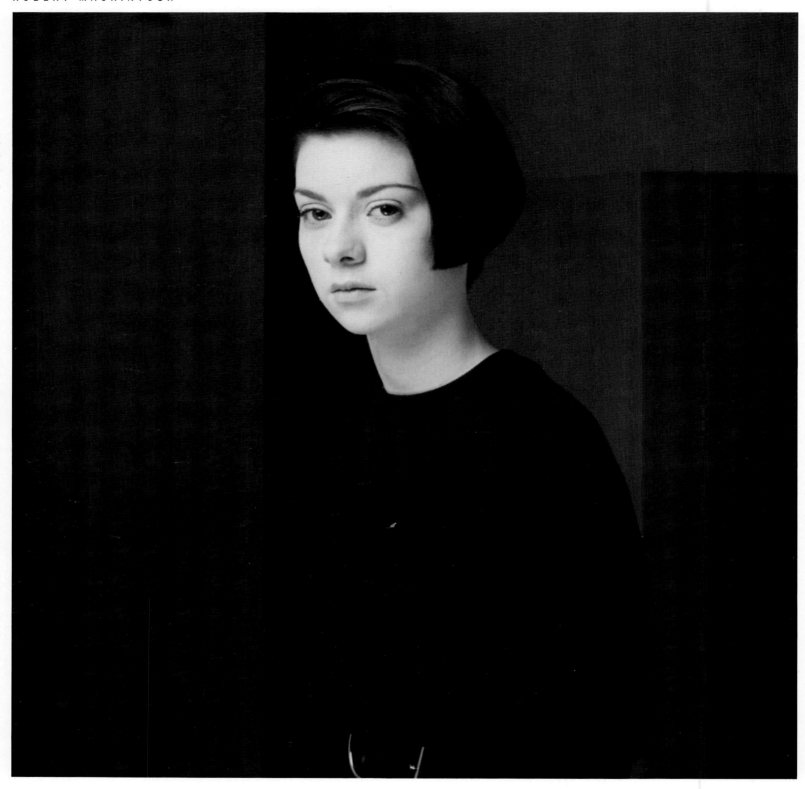

Andrew Kay
Designer · Maquettiste · Gestalter

Self-promotional poster.

Promotion personelle.

Eigenwerbungs-Plakat.

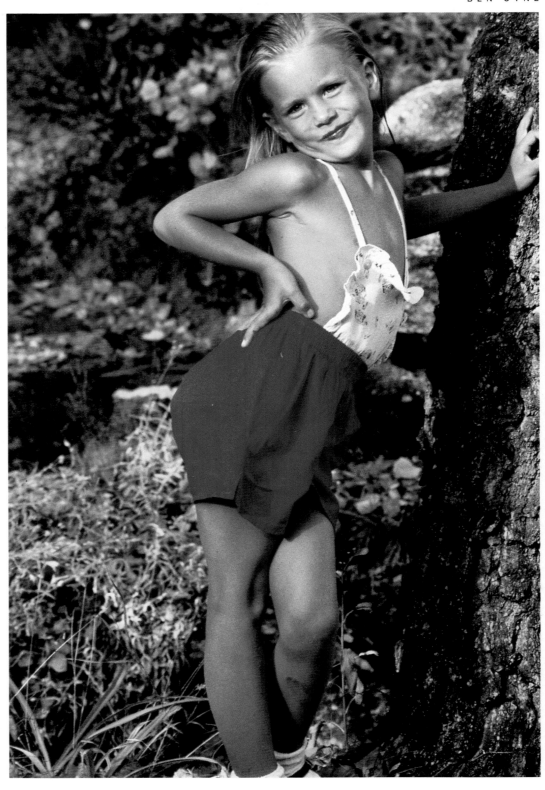

1
4
5

Joanna on a Swedish Vacation. Self-promotional book: Ben
Oyne – 10 years of Advertising Photography.

Joanna en vacances en Suède. Livre auto-publicitaire: Ben
Oyne – 10 ans de photographie publicitaire.

Joanna auf Urlaub in Schweden. Buch zur Eigenwerbung:
Ben Oyne – 10 Jahre Werbefotografie.

Ben Oyne
Art Director · Directeur Artistique · Art Direktor

Ben Oyne
Publisher · Editeur · Verleger

1
4
7

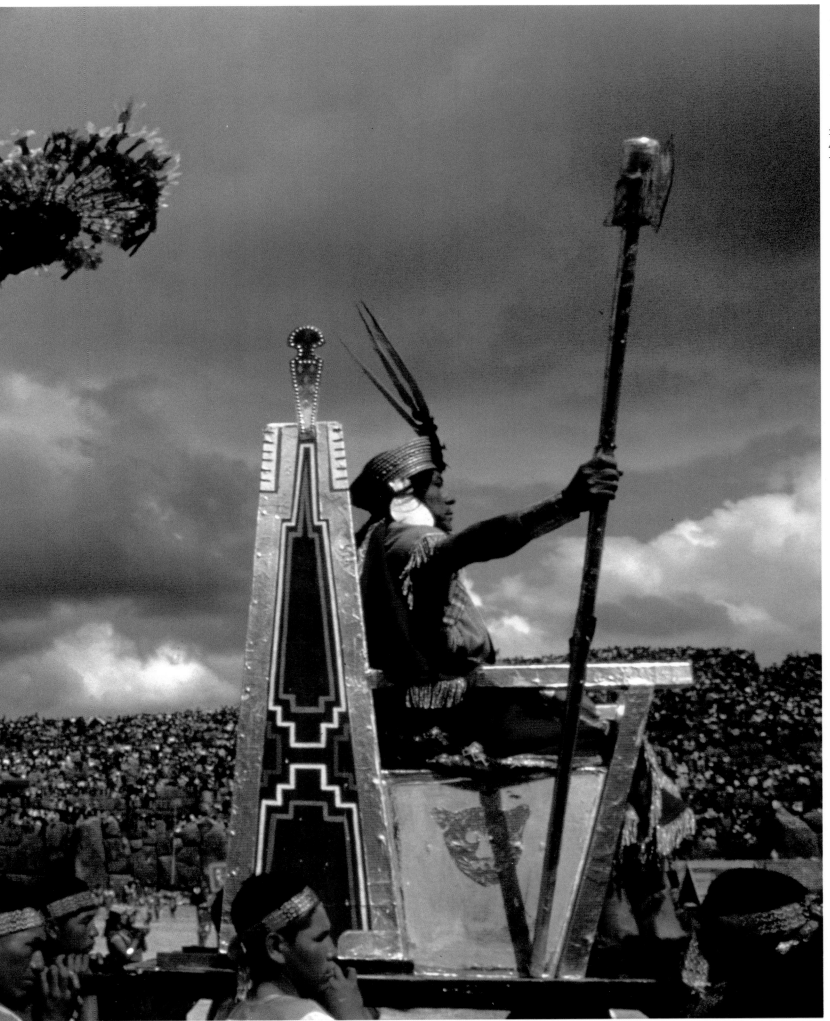

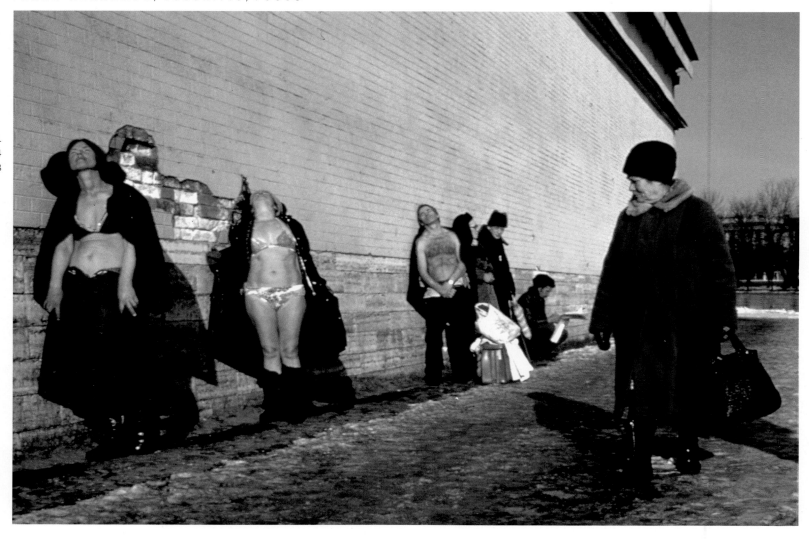

Pages 146, 147 The Soldier and the Inca, Cusco, Peru.

The New Pyramid Press Le Soldat et L'Inca, Cusco, Peru.
Art Director · Directeur Artistique · Art Direktor
 Der Soldat und die Inka, Cusco, Peru.

Robert Hadrill
Designer · Maquettiste · Gestalter

John Hemming
Writer · Auteur · Autor

The New Pyramid Press: The New Incas
Publisher · Editeur · Verleger

This page Spring on the Newa.

Franz Epping Printemps sur la Newa.
Art Director · Directeur Artistique · Art Direktor
 Frühling an der Newa.

Gerhard Äckerle
Picture Editor · Directeur de Photographie · Bildredakteur

Stern Year Book, 1983
Publisher · Editeur · Verleger

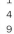

When the earth shook in Anatolia.　　Franz Epping
　　　　　　　　　　　　　　　　　　Art Director · Directeur Artistique · Art Direktor
Lorsque la terre a tremblé en Anatolie.
　　　　　　　　　　　　　　　　　　Gerhard Äckerle
Als in Anatolien die Erde Bebte.　　Picture Editor · Directeur de Photographie · Bildredakteur

　　　　　　　　　　　　　　　　　　Stern Year Book, 1983
　　　　　　　　　　　　　　　　　　Publisher · Editeur · Verleger

1 ——
5 ——
1 ——

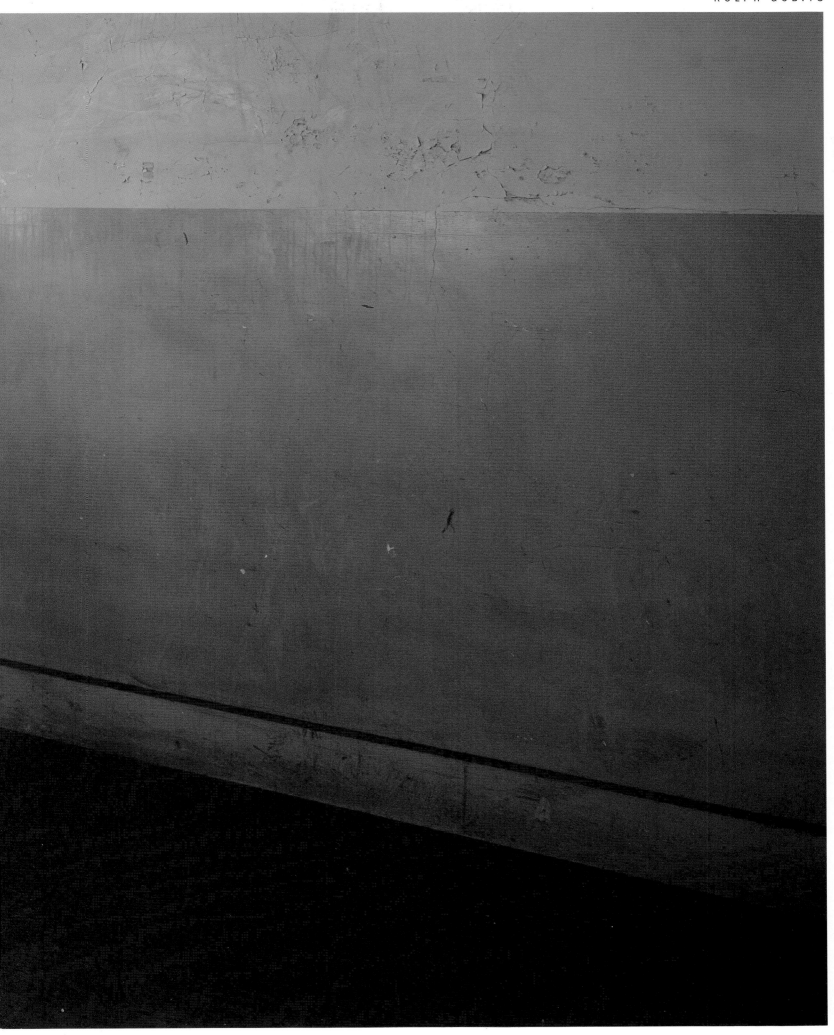

1
5
3

Pages 152, 153	Shot in the Putney Territorial Army Building.
Bill Thompson Art Director · Directeur Artistique · Art Direktor	Photographié dans le bâtiment de l'Armée Territoriale à Putney.
Sue Henry Copywriter · Redacteur · Texter	Aufgenommen im Gebäude der Territorialen Armee in Putney.
WAHT Advertising Agency · Agence Publicitaire · Werbeagentur	
Sunday Colour Supplements, October 1983 Publisher · Editeur · Verleger	
This page	A photographic profile for Alexon by Lategan.
Paul Arden Art Director · Directeur Artistique · Art Direktor	Un profil photographique par Lategan pour Alexon.
	Ein Foto-Profil von Lategan für Alexon.
Tim Mellors Copywriter · Redacteur · Texter	
Saatchi & Saatchi Garland Compton Advertising Agency · Agence Publicitaire · Werbeagentur	
Alexon Client · Client · Auftraggeber	
Condé Nast, Vogue Magazine, March 1984 Publisher · Editeur · Verleger	

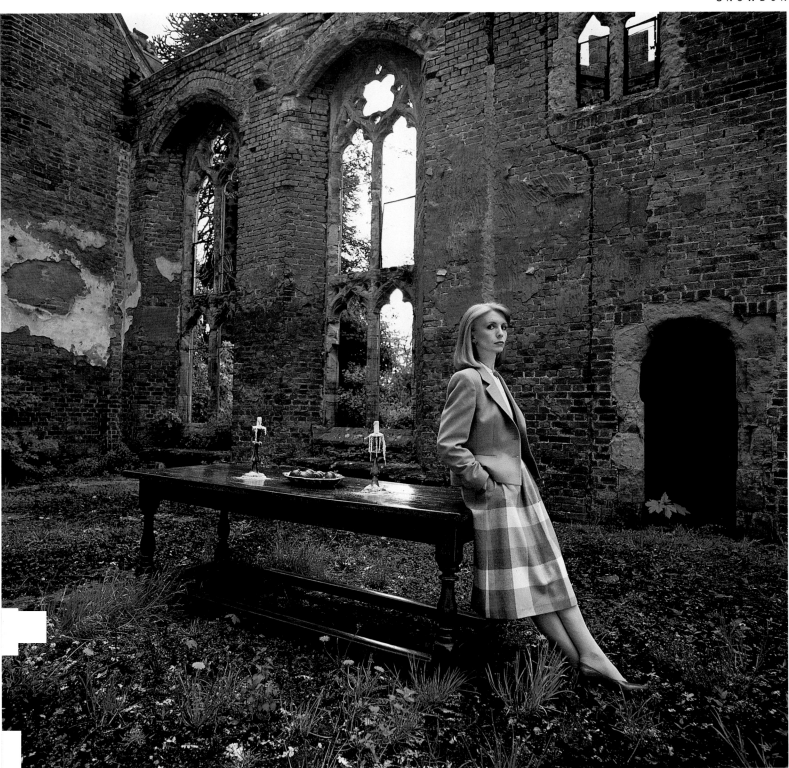

In the Grand Manor. Paul Arden
 Art Director · Directeur Artistique · Art Direktor

Dans le grand manoir.

Im großen Herrensitz. Tim Mellors
 Copywriter · Redacteur · Texter

 Saatchi & Saatchi
 Advertising Agency · Agence Publicitaire · Werbeagentur

 Alexon & Co. Limited
 Client · Client · Auftraggeber

 Vogue, April 1983
 Publisher · Editeur · Verleger

Uli Weber	Advertisement for Lancia.
Art Director · Directeur Artistique · Art Direktor	
	Publicité pour Lancia.
Ben Oyne	
Designer · Maquettiste · Gestalter	Werbung für Lancia
Leonhard & Kern	
Advertising Agency · Agence Publicitaire · Werbeagentur	
Fiat/Lancia, Germany	
Client · Client · Auftraggeber	
Stern, Der Spiegel	
Publisher · Editeur · Verleger	

Page 157	Red Monarch. Film Poster for Cannes Film Festival 1983
John Gorham/Howard Brown	Monarque Rouge. Affiche de film pour le Festival de Cannes
Art Director · Directeur Artistique · Art Direktor	1983
Dennis Davidson Associates Limited	Roter Monarch. Film-Plakat für das Cannes Film Festival
Advertising Agency · Agence Publicitaire · Werbeagentur	1983
Enigma Productions Limited & Goldcrest Films Limited	
Client · Client · Auftraggeber	

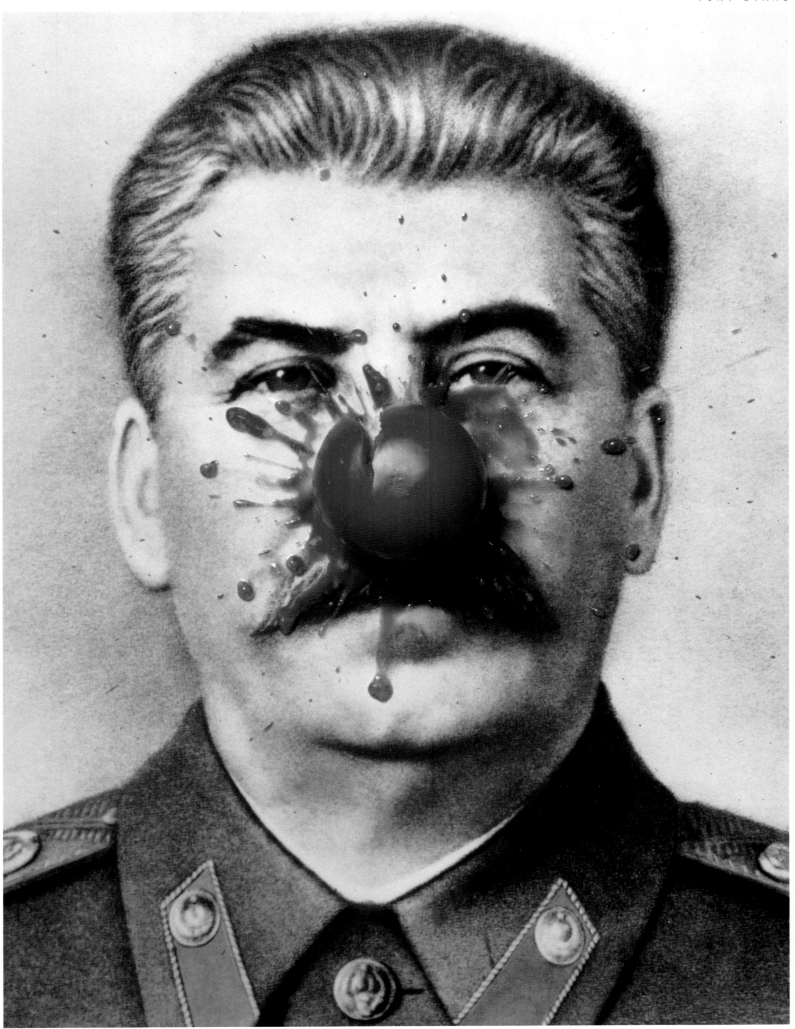

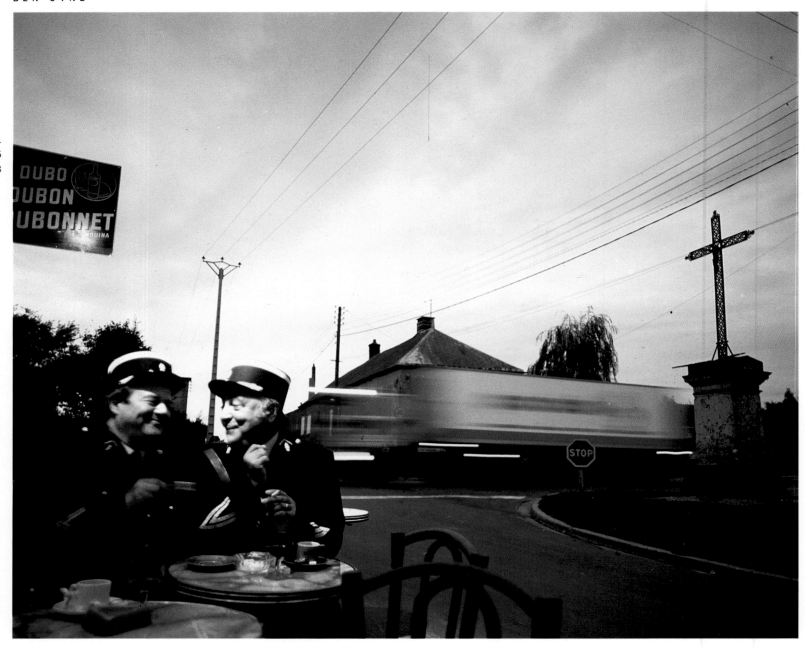

Jürgen Mandel
Designer · Maquettiste · Gestalter

Advertising Agency · Agence Publicitaire · Werbeagentur

TBWA
Advertising Agency · Agence Publicitaire · Werbeagentur

Père Dodu – Poultry
Client · Client · Auftraggeber

Stern, Der Spiegel
Publisher · Editeur · Verleger

Père Dodu advertisement.

Publicité pour Père Dodu.

Werbung für Père Dodu.

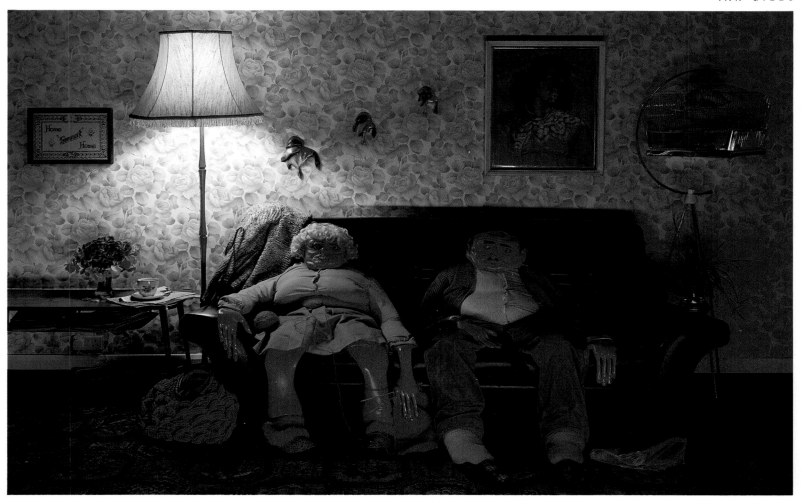

1 ——
5 ——
9 ——

Studio shot of set build and life-size models built by Dick Turpin.

Décor et modèles grandeur nature faits par Dick Turpin et pris en studio.

Studio-Aufnahme mit lebensgroßen Modellen, gebaut von Dick Turpin.

Kevin Jones
Art Director · Directeur Artistique · Art Direktor

Paul Hodgkinson
Copywriter · Redacteur · Texter

K.M.P.
Advertising Agency · Agence Publicitaire · Werbeagentur

Gloworm T.I. Limited
Client · Client · Auftraggeber

Trade Press, Summer 1983
Publisher · Editeur · Verleger

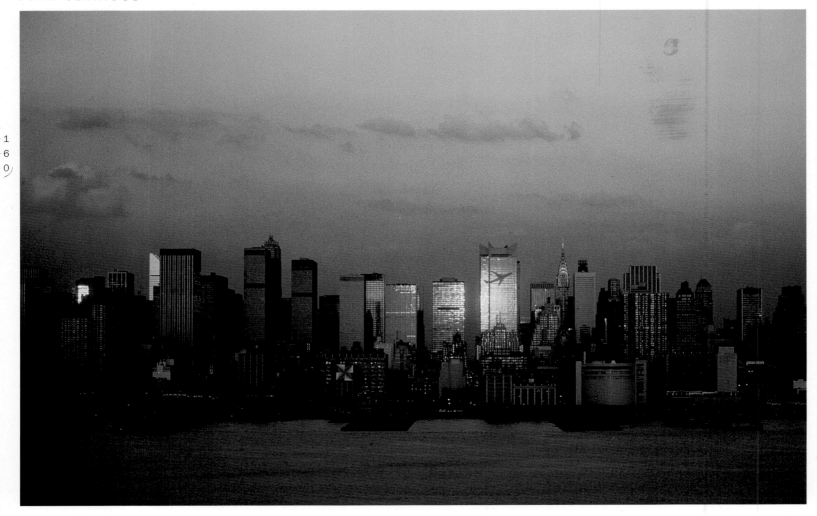

Graham Cornthwaite
Art Director · Directeur Artistique · Art Direktor

New York Skyline. Copyline: 'We Fly More People to More Countries Than Any Other Airline.'

Geoff Seymour
Copywriter · Redacteur · Texter

Ligne d'horizon New Yorkaise. Slogan: 'Nous emmenons plus de gens vers plus de pays que tout autre compagnie aérienne.'

Saatchi & Saatchi
Advertising Agency · Agence Publicitaire · Werbeagentur

New York Skyline. Slogan: 'Wir fliegen mehr Passagiere in mehr Länder als jede andere Fluggesellschaft.'

British Airways
Client · Client · Auftraggeber

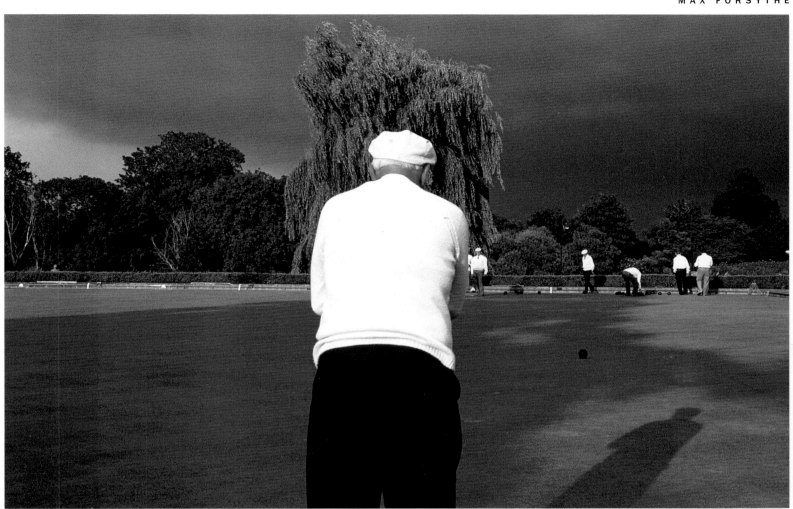

Advert for Max Forsythe Exhibition and Ilford film.

Publicité pour l'exposition de Max Forsythe et les pellicules Ilford.

Werbung für eine Ausstellung von Max Forsythe und Ilford Film.

Simon Minchin
Art Director · Directeur Artistique · Art Direktor

Ilford
Client · Client · Auftraggeber

1 ———
6 ———
3 ———

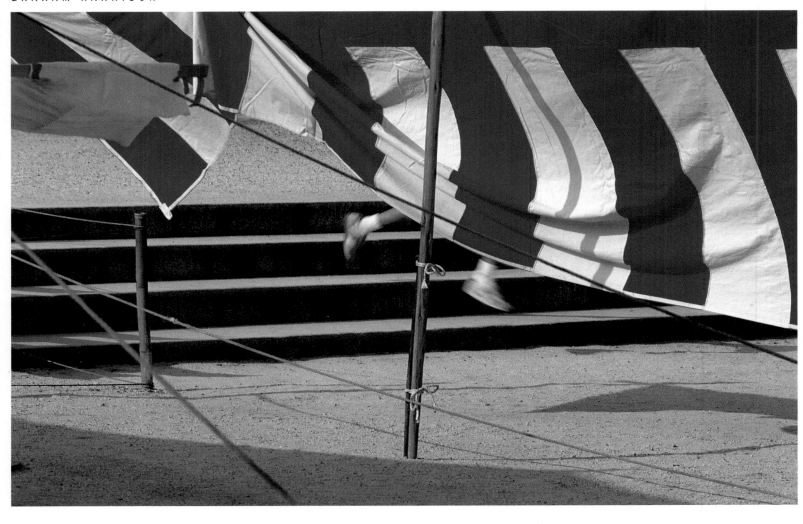

Taken during the Takigi Noh at the Heian Shrine in Kyoto,
Japan.

Pris pendant le Takigi Noh au lieu-saint de Heian, Kyoto,
Japon.

Aufgenommen während des Takigi Noh im Heian Schrein in
Kyoto, Japan.

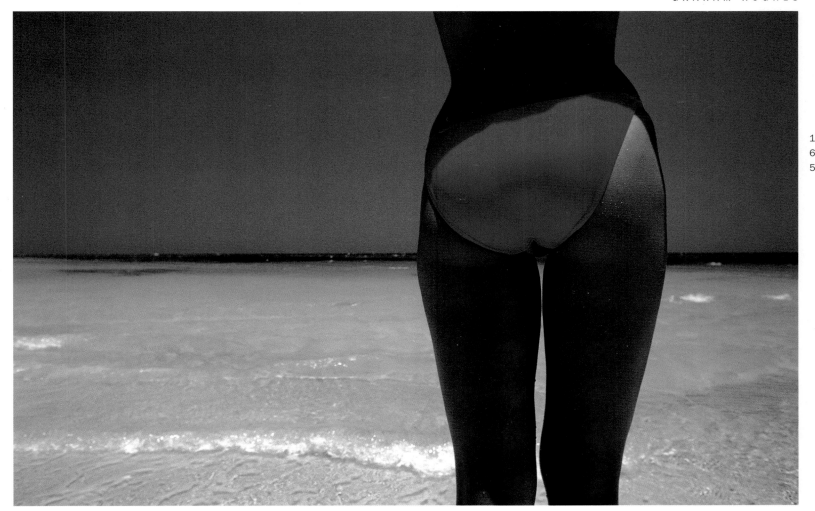

Louise King in Jamaica.

Louise King en Jamaique.

Louise King in Jamaika.

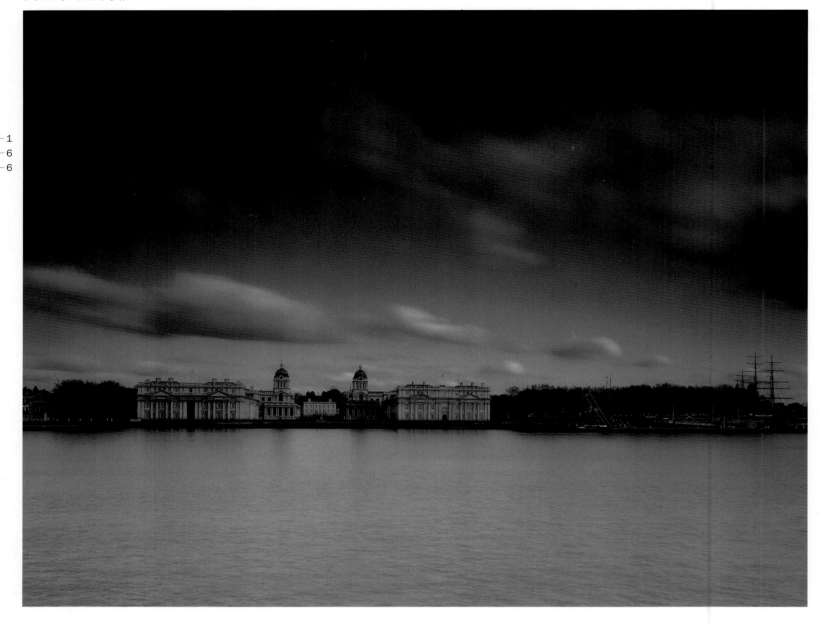

Greenwich Maritime Museum from the Isle of Dogs, London.

Le Musée Maritime de Greenwich photographié de l'Isle of Dogs, Londres.

Das Maritime Museum, Greenwich, aufgenommen von der Isle of Dogs, London.

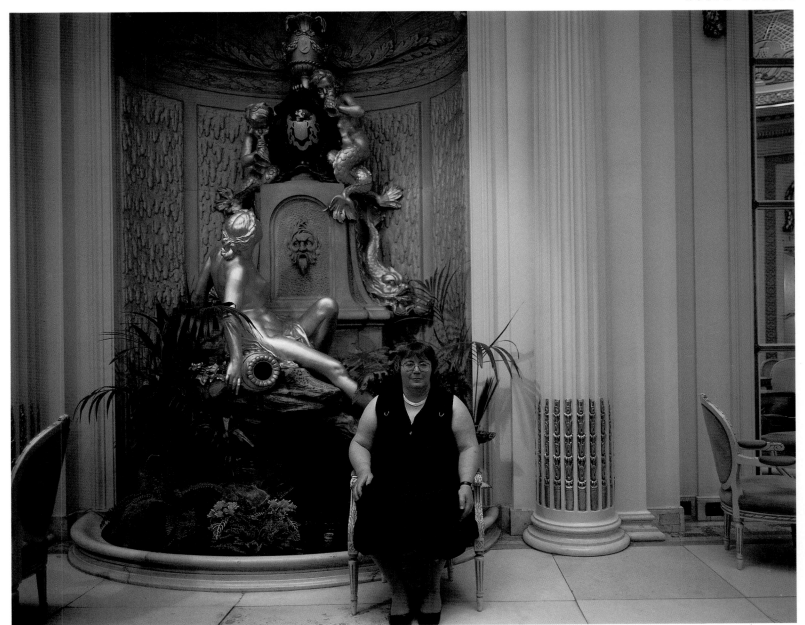

The Ritz Hotel, London.

Le Ritz Hotel, Londres.

Das Ritz Hotel, London.

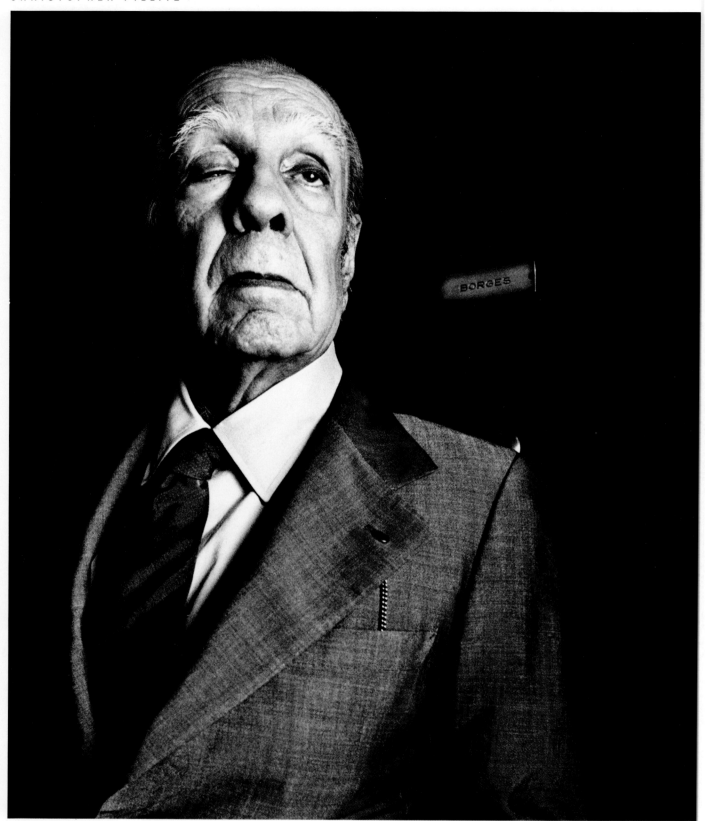

Jorge Luis Borges

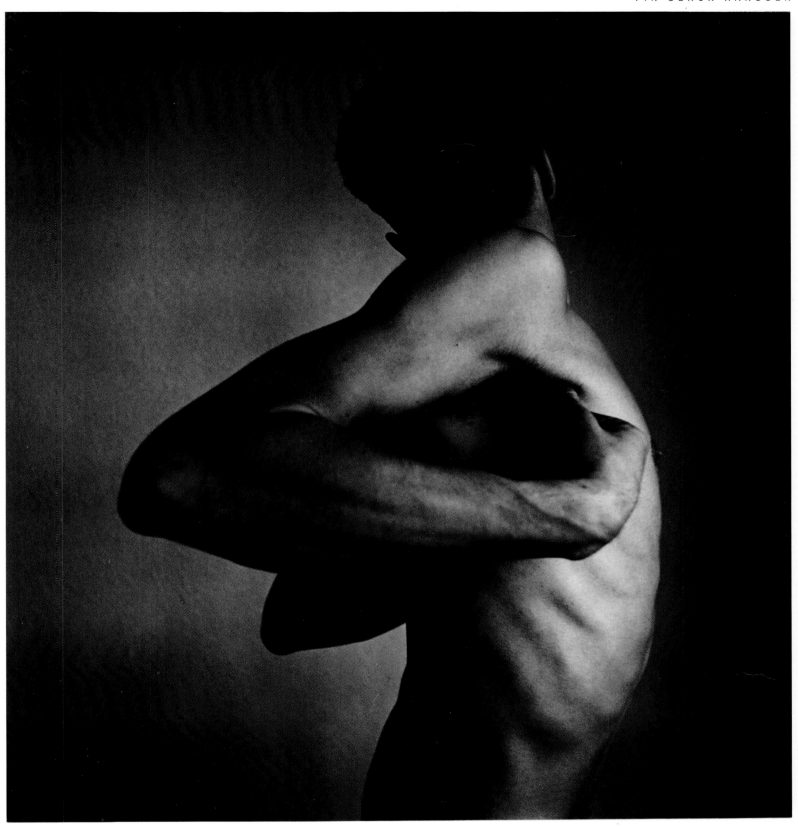

Mike I. Derby College of Higher Education
 College · Ecole · Kunstschule

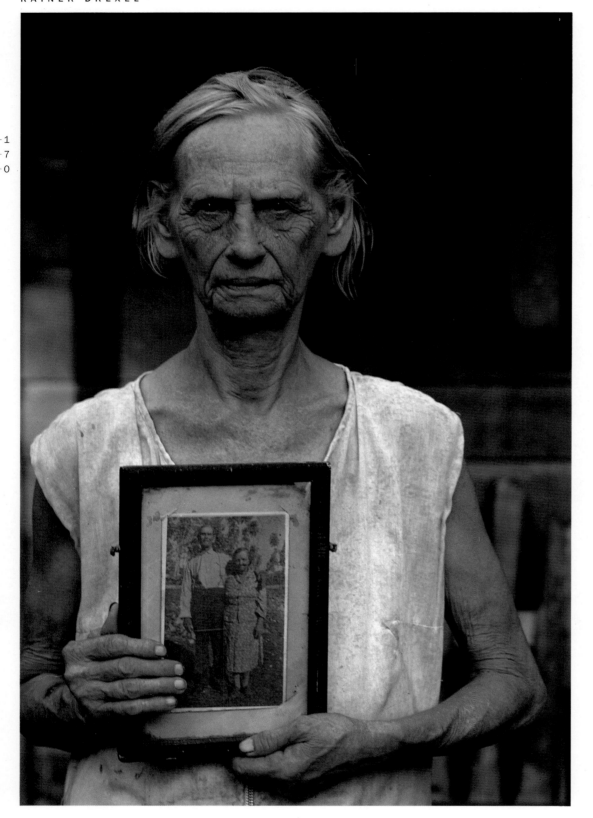

Gladis Kemeka with a picture of her parents in Seaford
Town, Jamaica, which was founded by German immigrants
in 1834.

Gladis Kemeka avec une photo de ses parents à Seaford
Town Jamaïque, fondée par des immigrés allemands en
1834.

Gladis Kemeka mit einem Bild ihrer Eltern in Seaford Town,
Jamaika, das 1834 von deutschen Einwanderern gegründet
wurde.

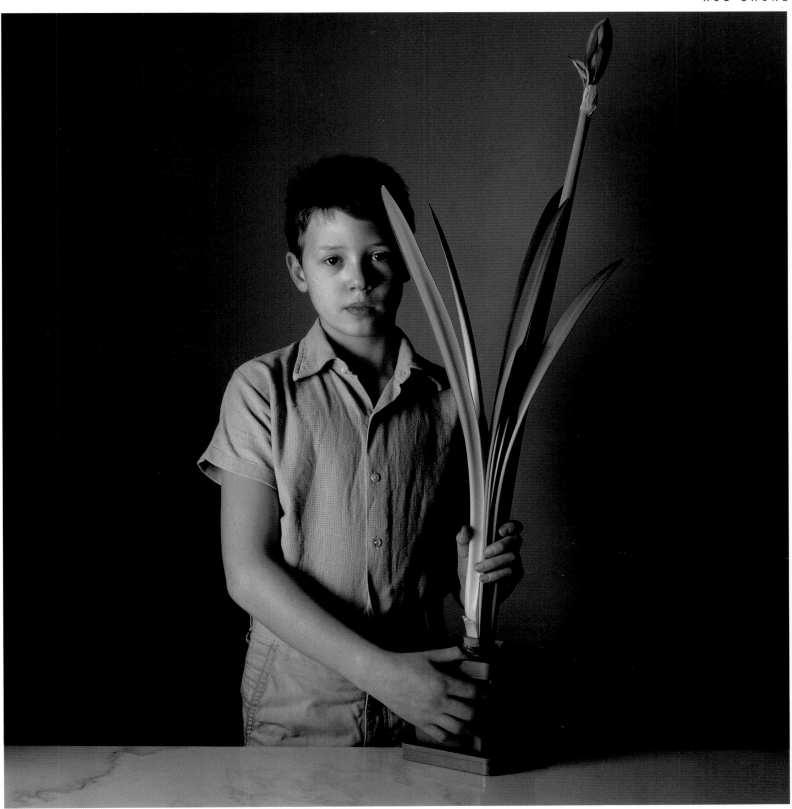

Young boy with amaryllis.

Jeune garçon avec amaryllis.

Junge mit Amaryllis.

1
7
2

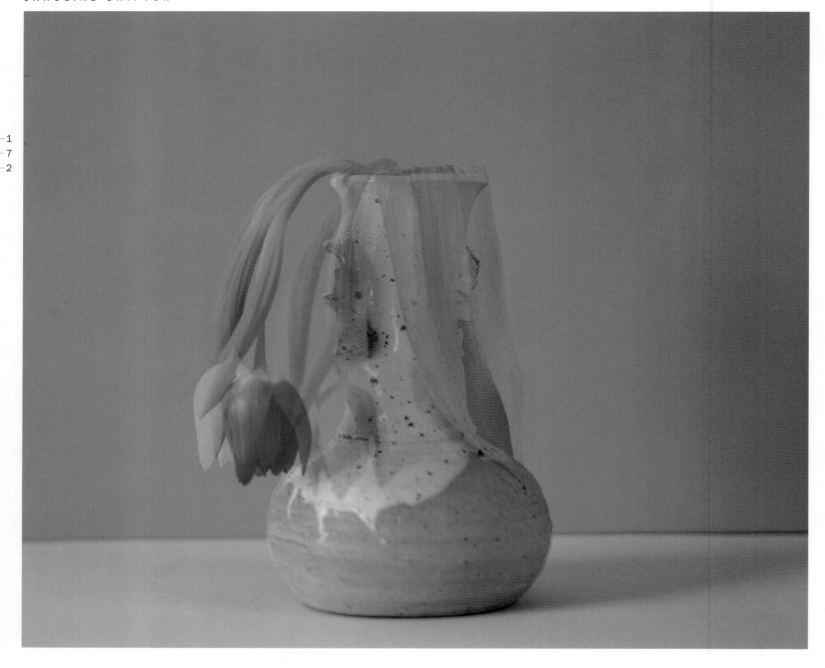

Derby College of Higher Education Unstill Life.
College · Ecole · Kunstschule

Nature non-morte.

Un-Stilleben.

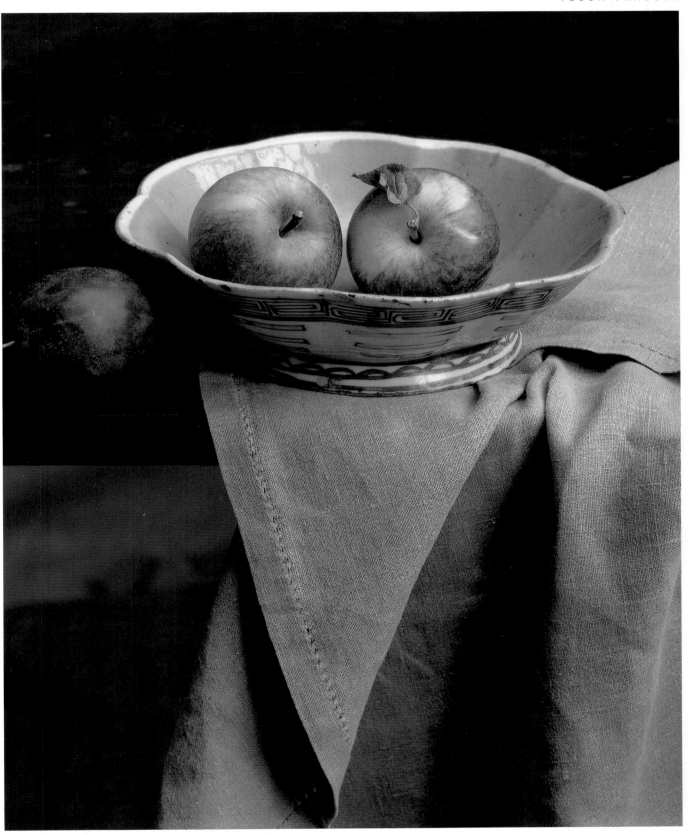

Apples.

Pommes.

Äpfel.